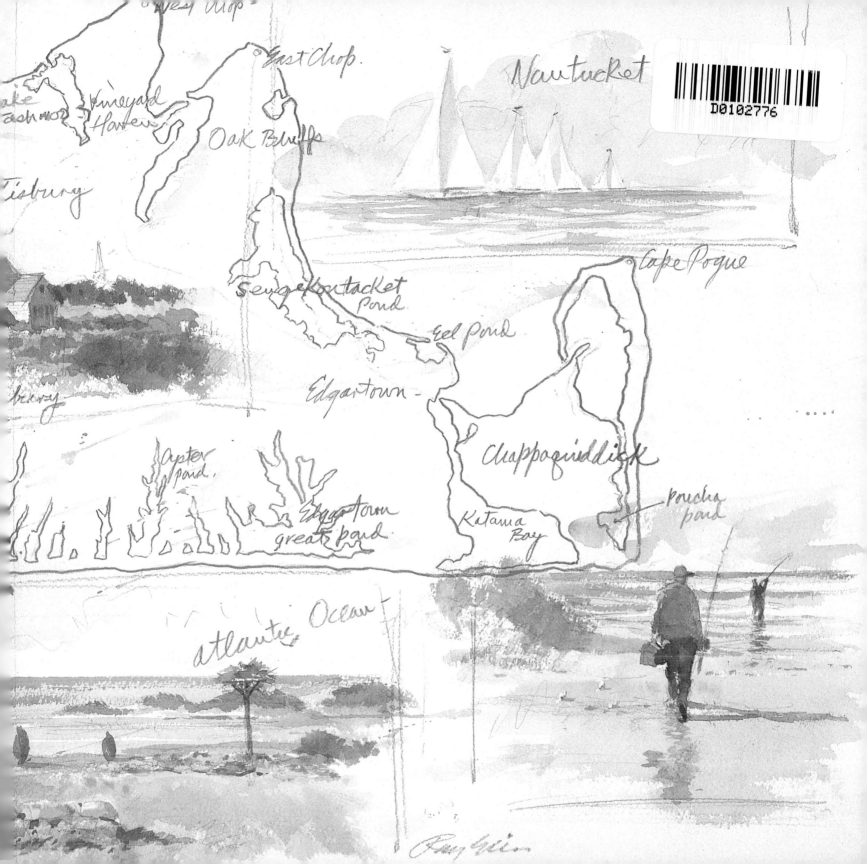

West Chop

East Chop

Nantucket

ke ashmo

Vineyard Haven

Oak Bluffs

Tisbury

Sengekontacket Pond

Cape Pogue

Eel Pond

bury

Edgartown

Oyster Pond

Chappaquiddick

Edgartown great pond

Katama Bay

Poucha Pond

atlantic Ocean

Martha's Vineyard

An Affectionate Memoir

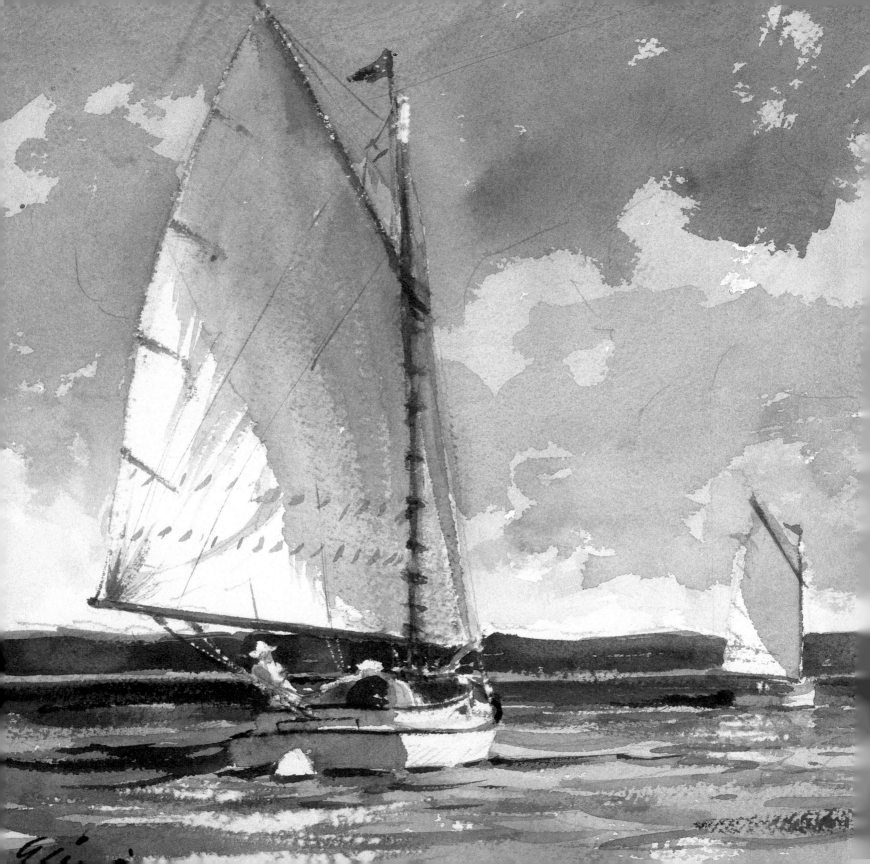

Martha's Vineyard

An Affectionate Memoir

Ray Ellis (signature)

25 Years of Paintings by Ray Ellis
400 Years of History by Ralph Graves

Abbeville Press Publishers
New York London Paris

To Teddie,
 my Island girl
 Ray Ellis

To Eleanor, for all the
 Chilmark years
 Ralph Graves

Front cover: Detail of *From Chappy Shores* (see p. 86).
Back cover: Detail of *Pogue Picnic* (see p. 92).
Endpapers: *Map of Martha's Vineyard, 1994.*
Page 2: Detail of *Fresh Breeze* · 1993 · WATERCOLOR
 11 X 15 IN. (27.9 X 38.1 CM).
Page 4: *Haying at Thimble Farm* · 1990 · OIL · 20 X 30 IN. (50.8 X 76.2 CM).
Page 5: top, detail of *Harbor Garden* (see p. 58); center, detail of *A Day at the
 Beach* (see p. 96); bottom, *Fishing the Breakwater* (see p. 136).

EDITOR: Susan Costello
DESIGNER: Molly Shields
PRODUCTION EDITOR: Owen Dugan
PRODUCTION MANAGER: Lou Bilka

First edition
10 9 8 7 6 5 4 3 2 1

Library of Congress Cataloging-in-Publication Data
Ellis, Ray G.
 Martha's Vineyard : an affectionate memoir / 25 years of paintings by
Ray Ellis ; 400 years of history by Ralph Graves.
 p. cm.
 Includes index.
 ISBN 1-55859-866-9
 ISBN 0-7892-0039-2 (collector's edition)
 1. Ellis, Ray G.—Themes, motives. 2. Martha's Vineyard (Mass.) in art.
3. Martha's Vineyard (Mass.)—History. I. Graves, Ralph. II. Title.
ND1839.E43A4 1995
759.13—dc20 94-41486

Contents

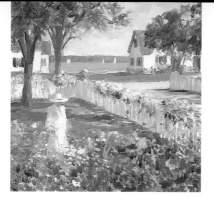

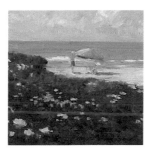
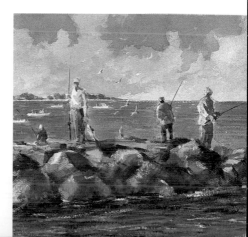

Artist's Acknowledgments

Sincere thanks go to Treesa Germany, my gallery director, for researching the whereabouts of all the paintings and cataloguing them; to Ross Meurer for photographing most of the paintings for reproduction in this book; and to my wife Teddie for her faith in me, her encouragement and her hard work.

Author's Acknowledgments

This is not an historian's history, so there are no footnotes and no formal bibliography. However, certain books and certain people made this account possible.

Several of Henry Beetle Hough's books, especially *Martha's Vineyard—Summer Resort After 100 Years,* were extremely helpful. So were *An Introduction to Martha's Vineyard* by Gale Huntington and the brief *Guide to Martha's Vineyard* by Polly Burroughs. The three-volume *History of Martha's Vineyard* by Charles Edward Banks was useful for genealogy. The Dukes County Historical Society, the Martha's Vineyard Preservation Trust, the Vineyard Conservation Society and the Sheriff's Meadow Foundation provided important information from their files.

Ann Nelson, owner of the outstanding Bunch of Grapes bookstore in Vineyard Haven, encouraged the project from the beginning, steered me to the right books, and read the first draft of my manuscript, recommending valuable additions. Edith Potter, Dionis Riggs, David Flanders, Everett Poole and Gus Ben David gave me such lively interviews that I had to create separate "boxes" for them outside the main narrative text. Peter Van Tassel, library assistant and council member at the Dukes County Historical Society, read the finished manuscript and contributed corrections and additional research.

I owe special thanks to Richard and Jody Reston, editor and publisher of the *Vineyard Gazette,* who opened their files to me. Since the paper is almost 150 years old, it is the best record for a substantial part of my account. Fortunately for me, Eulalie Regan, the *Gazette*'s librarian for the last eight years, can find absolutely anything on any subject in no time at all. Anyone who wants to write about the Vineyard had better make friends with Eulalie Regan.

Preface by Ray Ellis

For the past 25 years I have lived either on or near an island. And I probably have visited more than a hundred others all over the world, many during my time in the U.S. Coast Guard in the 1940s. After seeing and painting so many islands, I chose Martha's Vineyard as my final home and destination.

When Teddie and I married in 1985, we began spending seven months at our home in Savannah, Georgia, and five months at our home on the Vineyard. It became harder and harder for us to leave the Island when time was up. Having both grown up in the North, we missed the change of seasons in Savannah. We missed the sight of a stand of yellow maples. We missed snow—or at least cold weather—for Christmas. We missed seeing purple crocuses at a sunny turn of the barn. We had both grown up in small towns and missed the close-knit, caring spirit that comes from truly knowing one's neighbors. We also feel a certain independence—whether real or imagined—when living on the Island. It's a little harder for us to get somewhere else, and it's a little harder for others to get to us!

In June of 1991, we made our last trip from Savannah to the Vineyard in our station wagon loaded with studio supplies, two cats, a dog and a parrot. The moving van followed shortly thereafter, and we became full-time residents of the Vineyard, a decision we have never regretted.

Many of the subjects I have painted on the Island are pastoral and tranquil landscapes. I also enjoy painting the sea in all its various moods. Harbors, too, fascinate me with the comings and goings of all types of craft in all kinds of weather. But this Island is made up of much more than beautiful gardens, meadows, harbors, yachts and houses with roses on white picket fences. It is made up of diverse people from all walks of life—tradesmen, fishermen, retirees, young families, farmers, shopkeepers, innkeepers, professionals, writers, artists and, in July and August, a large number of tourists and summer residents. I try to depict all of this Island life by painting what I see in every season of the year.

But I also must try to see what makes a good composition. I have no problem removing a telephone pole or adding a pot of red geraniums in a window if I feel doing so will make a better painting. I also avoid painting painful or ugly subjects, such as a Canada goose hovering over her dead mate or a doe killed on the highway. I may be accused of viewing life through rose-colored glasses, but I honestly believe that newspapers and television provide us with enough sordid realism to last a lifetime. I want to paint a kinder, gentler way of life, and the Vineyard gives me ample material.

Although I have painted all over the Island, Edgartown is where my home and studio have always been. I walk in Edgartown, bike around there and shop there. Consequently, a majority of my paintings are of Edgartown and its vicinity. But one of the joys of doing this book was looking for material in places I had never been before. I am determined to do more exploring.

Allow me to dispel a myth that there are only a few places on this earth where an artist can find a distinctive and exclusive light. We have all heard about the "light" in such places as the Greek Islands, Venice, Portugal and Taos. I have painted in all these locations, and I would rate the "light" on the Vineyard with the best of them. But artists need much more than light. They need a variety of subject matter, a distinctive character or flavor and human interest, which means different kinds of people doing different things. In other words, artists need a sense of place that bears recording.

My work habits have changed by necessity over the years. From 1932, when I did my first watercolors, until 1969, when I made painting a full-time career, I did 90 percent of my paintings outdoors on location. But as my paintings became more in demand and my productivity increased, the studio became more and more my working place. I no longer could afford to wait three days for the weather to clear before I could do a plein–air painting. I now sketch and take photographs on the spot and return to my studio armed with those sketches and pictures, particularly for architectural detail and reference. I might add that most landscape and seascape painters have used photography as a tool for well over 100 years.

One of the questions I am most frequently asked is: "What artists have influenced you the most in your painting career?" I always answer by talking about my funnel theory. In my studios I have always kept a vast art library, which I add to whenever I see an interesting new book. I spend many hours studying the work of artists I admire, such as Monet, Homer, Sargent, Chase, Sisley, Sorolla, Wyeth and my old mentor and friend Ogden Pleissner. I then put what I like into my brain, which serves as a funnel. What comes out from my hand on paper or canvas is my own personal style, tempered in varying degrees by what I have seen and studied from painters I like.

I always stress in my lectures and workshops that no one should allow himself to be overly influenced by just one artist. I think that, as an artist, the greatest compliment I can be paid is to have a person walk into a room, look at a painting and immediately say, "That's an Ellis." Years ago I was painting outdoors on School Street in Edgartown when a lady came up to me and said, "You paint just like an artist who used to live in

New Jersey named Ray Ellis." Needless to say, she made my day, and we have become good friends since.

Many artists have painted on the Vineyard, some as residents, others as visitors. The most notable was Thomas Hart Benton, whose depictions of Island life became legendary, and many of his works are in the collections of the country's most prestigious museums. I had the pleasure of meeting Benton back in the 1970s when he spoke at the Old Whaling Church. He was more opposed to the "modern" movement than any other artist I had ever met, and for a man of small stature he could express himself like a feisty bantam rooster. Jackson Pollock studied for a time with Benton at his Chilmark studio, though Pollock obviously did not derive his technique from those lessons! Others who painted here include Edward Hopper, Vaclav Vytlacil and Frank Vining Smith. Strangely enough, the Vineyard—in spite of all its artists past and present—has never really been known as an "artists' colony" in the vein of Provincetown, Taos or Greenwich Village. I honestly don't know why a colony never developed here, because for me it has all the necessary ingredients to make it a wonderful place to paint.

This book has been a labor of love. I love what I do, and I love where I do it. As I approach my 73rd year, I honestly feel as though I have come "home." The Vineyard is the only place I have ever been where, when I am there, I never want to be anywhere else.

Foreword by Ralph Graves

When I first started coming to the Vineyard, as a teenager in the late 1930s, I found the 45-minute ferry ride from Woods Hole to Vineyard Haven interminable. From the moment we left the mainland, I could see the Island, but it took forever to reach the West Chop lighthouse and then to steam, at painfully slow speed, all the way down to the harbor and the ferry landing.

On the way, the boat passed right in front of our house, which stood on a low bluff midway between the lighthouse and the landing. All summer long, a dozen times a day, as the ferry went into or out of Vineyard Haven, my mother would look out the front windows and announce, "There goes the ferry." I couldn't wait to get to our house, to all the competitive games with my brothers, to the corn and the swordfish, to the family picnics, to the surf-riding at Stonewall Beach. I knew of one older gentleman who always slipped into the men's room during the ferry ride and changed from his city clothes to his shorts so that he would be not only sartorially but also emotionally ready to step onto the Island. I knew how he felt.

Now, all these years later, 45 minutes seems just right for the ferry trip. It is enough time to distance myself from whatever hassle it took to reach Woods Hole. It is enough time to enjoy the thought that I am traveling to a piece of land that is clearly and totally separated from anything else by this stretch of ocean. It is enough time to appreciate the fact that I am almost there, almost home, coming back once again.

* * *

Over the years I have learned many important things about the Vineyard:

The way the afternoon fog looks, soft and gray and moist and thick, when it flows in from Gay Head and Squibnocket, then drifts down-Island and settles into the valley of Middle Road.

When not to buy lobsters because they will be watery.

Where to take small children for diversion on a third consecutive day of rain.

How to keep skunks and raccoons out of trash barrels.

The right week in April to see the blooming of daffodils—or, later, the right week for beach plums and daisies and Queen Anne's lace and butterfly weed.

Where to find a parking place in Edgartown in August.

The difference between "native corn" and "Island corn," and the best place to buy tomatoes.

When to slow down for the horrible bumps on Tea Lane and Meeting House Road.

When it is safe to drive into Vineyard Haven for midsummer shopping without getting caught in either of the two traffic jams.

That July is usually better than August, and September is almost always better than either, and that October can be even better than September, while brown, bare, muddy March is a time to be somewhere else.

•　　　•　　　•

All this I knew. But I should have realized, both as a longtime journalist and novelist, that until you start to write about a subject, you don't realize how much you don't know. In the course of researching and writing this short history, I learned many new and interesting things about this place I thought I knew so well. Five Island residents told me such fascinating details about their own special areas that I have presented their words in separate "boxes."

I hope readers, even those who know the Island better than I, will enjoy making some of the same discoveries that I did.

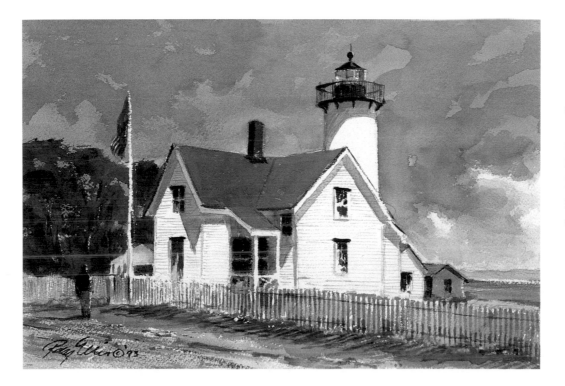

This is the first lighthouse one sees on the Vineyard after leaving Wood's Hole by ferry. It is also one of the most painted and photographed subjects on the Island.

West Chop Light
1993 • WATERCOLOR
11 X 14 IN. (27.9 X 35.6 CM)

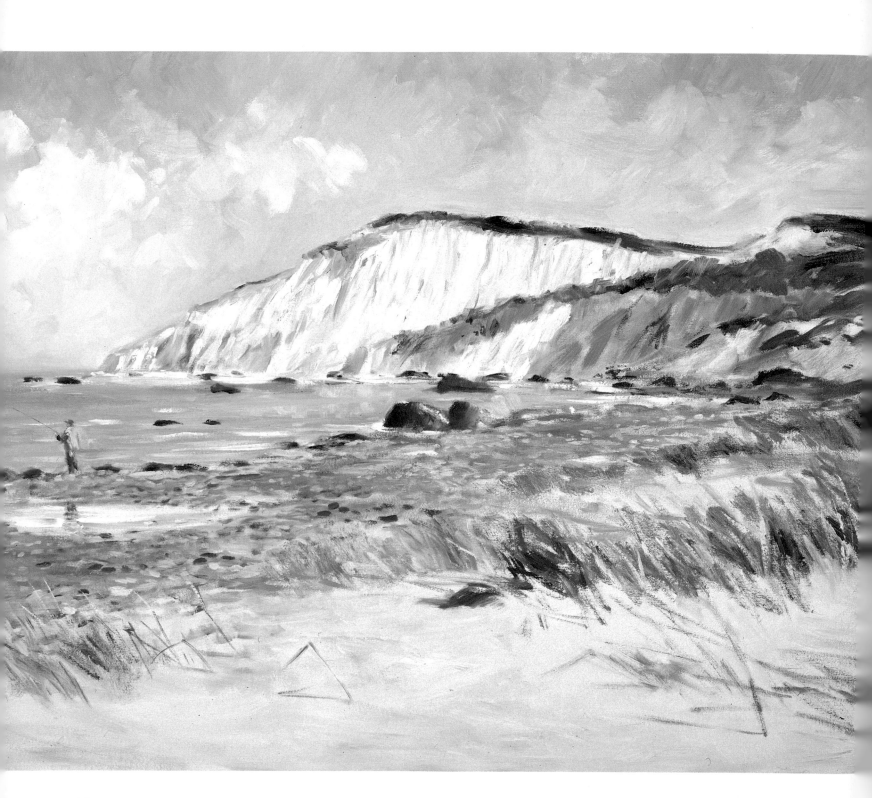

Martha's Vineyard

An Affectionate History

Who is the Martha of Martha's Vineyard? Martha of the long sandy beaches—and a good many rocky beaches, too. Martha of the abundant wild grapes that inspired the second half of her name. Martha of the Great Ponds fronting the Atlantic Ocean, their individual inlets stretching deep into the land like long, graceful fingers. Martha of the broad, flat sand plains and the rolling hills and the great colored clay cliffs of Gay Head, gaudy in a bright sunset. Martha of the pine-and-oak forests, the groves of beetlebung trees, the clumps of wild blueberry bushes and the immeasurable miles of intricately balanced stone walls. Who is this beautiful and beloved Martha?

Nobody knows. But we do know who bestowed the name. He was the English explorer Bartholomew Gosnold, who discovered the island in May of 1602. In fact, he bestowed the name twice—first on the small nearby island of Noman's Land, his initial landing place. But when he reached the much more impressive main island, he transferred the name.

Island chroniclers and historians have devoted much speculation and many disputes to the identity of Martha. She was Gosnold's mother. No, she was Gosnold's daughter, who died in infancy. (Some years after his voyage of discovery he had another daughter whom he also christened Martha.) No, she was neither Gosnold's mother nor daughter but his mother-in-law, Martha Judde Golding. Few explorers name places after their mothers-in-law, but Gosnold's had helped raise money for his expedition. Besides, in addition to being his mother-in-law, she was also his aunt. Gosnold never said for whom he named his island. Perhaps he just liked the name Martha and bestowed it at every opportunity.

The Island, with a Capital *I*

It doesn't really matter anyway. Those who live on Martha's Vineyard or visit it regularly never use the full title except when explaining to an outsider where they prefer to be. As in: "I go to Martha's Vineyard. It's near Cape Cod." But to each other and in their own hearts they refer to it simply as "the Vineyard," or even more simply as "the Island," with a capital *I*.

No confusion exists about which "Island" they mean. For lovers of the Vineyard, it cannot possibly be Nantucket, another, smaller island even farther away from Cape Cod. Except for high-school athletic teams seeking to prove their superiority, no serious Vineyard person ever goes to Nantucket. If you are already on the Vineyard, why would you go to Nantucket? The Nantucket folks feel the same way about the Vineyard— although we think, of course, that they have far less justification.

Speculation about early Vineyard history does not end with the Martha conundrum. Some argue that the Viking chief Leif Erikson came to the Vineyard around the year 1000 and called it either Vineland or Straumey ("island of currents"). No shred of proof exists.

Another nice tale is that Shakespeare used Martha's Vineyard as the setting for his play *The Tempest*. The theory is that he could have learned about it from listening to Gosnold's shipmates raving about the wonders of the Vineyard at some handy London tavern. For this appealing speculation, not even a suspicion of a shred of proof exists.

A Whole Whale for Breakfast

Anybody who believes the Shakespeare story would probably accept the Moshup stories. Moshup was a mythical Vineyard Indian, a giant who lived in Gay Head on the western end of the Island. His name survives today in the Moshup Trail, a paved road that loops around Gay Head. Even when judged by the loose standards of myths, the Moshup yarns are farfetched. For his breakfast he often ate an entire whale, cooked by his wife Squant in a dead volcano. Cooking a whole whale requires a great deal of fuel, which Moshup provided by tearing trees out of the ground. That is why there are no trees in Gay Head. In addition to fancying whale meat, Moshup was fond of tobacco and smoked a huge pipe. Each night he dumped the ashes into the ocean in the same place, and lo! those ashes became Nantucket.

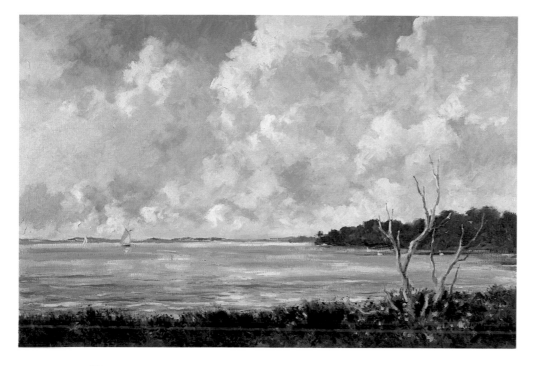

No doubt an equally unsavory Nantucket legend tells how Martha's Vineyard was created, but here is what really happened. During the age of the glaciers a vast sheet of ice crawled down from the north, pushing boulders, rocks and other debris before it and dragging more crushed debris underneath it. When it finally stopped and then retreated, some 10,000 years ago, it left behind something called a terminal moraine—in this case, Martha's Vineyard. The Island's many boulders and stones scattered across its landscape are the gift of the glacier. The flat sand plains and Great Ponds along the southern shore of the island, the result of glacial melting, are called outwash plains.

The retreating glacier did not leave the Vineyard an island. That happened several thousand years later when the ocean waters, rising as the glaciers melted, cut the Vineyard off from the mainland. All Vineyarders consider this an almost divine development. Opposition to the notion of building a connecting causeway to the mainland is intense and perpetual. Despite any inconvenience, of which there is a great deal, the sacred status of "Island"—isolated, separate, reachable only by plane or by a 45-minute ferry ride—is infinitely preferred.

No Stoplights, Only One Blinker

The Island is triangular, 20 miles long, nine miles wide, and roughly 100 square miles in area. The western end is hilly, with cliffs of sand and clay. Peaked Hill and Prospect Hill, the highest points on the Island, rise just over 300 feet. There are six towns, three big ones down-Island and three small ones up-Island. Each town is ferociously independent, which

is good for flavor and local color, less good for community cooperation. The Island is proud to boast that it does not have a single stoplight, and only one blinker light, which is on the main road from Vineyard Haven to Edgartown. This is good for civic pride, less good for traffic flow during July and August.

According to the Island's bible, the *Vineyard Gazette,* the year-round population is 14,000 and the summer population is 70,000. These numbers represent a large increase since the end of World War II, when the figures were only 6,000 and 40,000. The explanation is that the Island's charms have been discovered by more and more people, including Bill Clinton, who spent his first presidential vacation there in August 1993.

When Gosnold found and named the Island almost four centuries ago, the only inhabitants were the Wampanoag Indians. No one counted up how many they were—one estimate says around 3,000—but it is safe to assume that they were year-round residents, not summer people. Gosnold returned to England without founding any Vineyard settlement.

A Splendid Bargain at Forty Pounds

The Island and the Wampanoags were left undisturbed for four more decades until, in 1641, Thomas Mayhew, an Englishman living in the Massachusetts Bay Colony, bought the Vineyard from two other Englishmen who held disputing royal grants to the area. At a price of 40 pounds, Mayhew paid much, much more than the 25 dollars plus beads and trinkets that the Dutch supposedly paid the Indians for Manhattan. On the other hand, the Vineyard is three times bigger than Manhattan, it is much less crowded, the climate is nicer, the pollution is less, and the beaches are better. Furthermore, as part of the same deal, Mayhew picked up all the Elizabeth Islands and that former ash heap, Nantucket. Altogether a splendid bargain. Thomas Mayhew himself went on to become governor. He later sold off Nantucket for 30 pounds and two beaver hats.

The year after his father's purchase, Thomas Mayhew Jr. arrived with a small band of friends and built the first white settlement on the Vineyard. The settlers chose a place on the Island's southeast corner and called it Great Harbor, which would later become Edgartown. An attractive and deeply religious young man of 24, a graduate of Oxford who knew Greek, Latin and Hebrew, Mayhew was the first great figure in Vineyard history. He earned this distinction by converting the Wampanoag Indians to Christianity.

Gosnold's chronicler had described the Vineyard Indians as naturally courteous, gentle

and friendly, but if they remained that way after the invasion of settlers, it is almost certainly because Mayhew, during his years on the Vineyard, treated them with the greatest respect and love. The Indian wars that later took place all across New England, and then all across the country, never happened on the Vineyard.

The First Indian Convert

Mayhew's first convert was a man named Hiacoomes, who lived near Great Harbor. Out of curiosity, Hiacoomes attended the English church services, sitting silently in the back of the room. At first he did not formally adopt the faith, although Mayhew took pains to make friends with him. During that winter an epidemic swept through the Indian community. A great many caught the fever, and many died, but the family of Hiacoomes was miraculously untouched by the sickness. That was enough to convince him to join the church.

With the help of Hiacoomes, Mayhew added the Wampanoag language to his collection of tongues so that he could speak to the Indians about the Bible and Christianity in their own words. He preached all over the Island, traveling from one wigwam to another by horseback or on foot. He was a wonderful storyteller and could hold Indian groups spellbound with his dramatic tales from the Bible, told in their own language. He was much admired and liked, and as the years went by, he gained more and more converts.

He opened the first school on the Island to teach English to the Wampanoags. In 1657, after 15 years of missionary work, Mayhew decided to visit England, make a full report to his church, and bring back more teachers and books. He paid a series of farewell visits to his many Indian friends. He convinced them he was not deserting them but would return in a few months. Thomas Mayhew's last meeting with the Indians took place near what is now the airport road between Edgartown and West Tisbury. Then he sailed for England. Neither he nor his ship was heard from again.

A Loving Tribute in Stones

When the Wampanoags realized that their friend would never return, they made the scene of his last speech a sacred place. Whenever an Indian went near the spot, known as

Overleaf:

This barn on Middle Road in Chilmark is one of my favorites. The day I made a sketch for this painting, the hayloft doors were open. I could see the hay stacked on the right and then straight through to the hill beyond—sort of a painting within a painting.

Chilmark Farm · 1992 · OIL 20 X 28 IN. (50.8 X 71.1 CM)

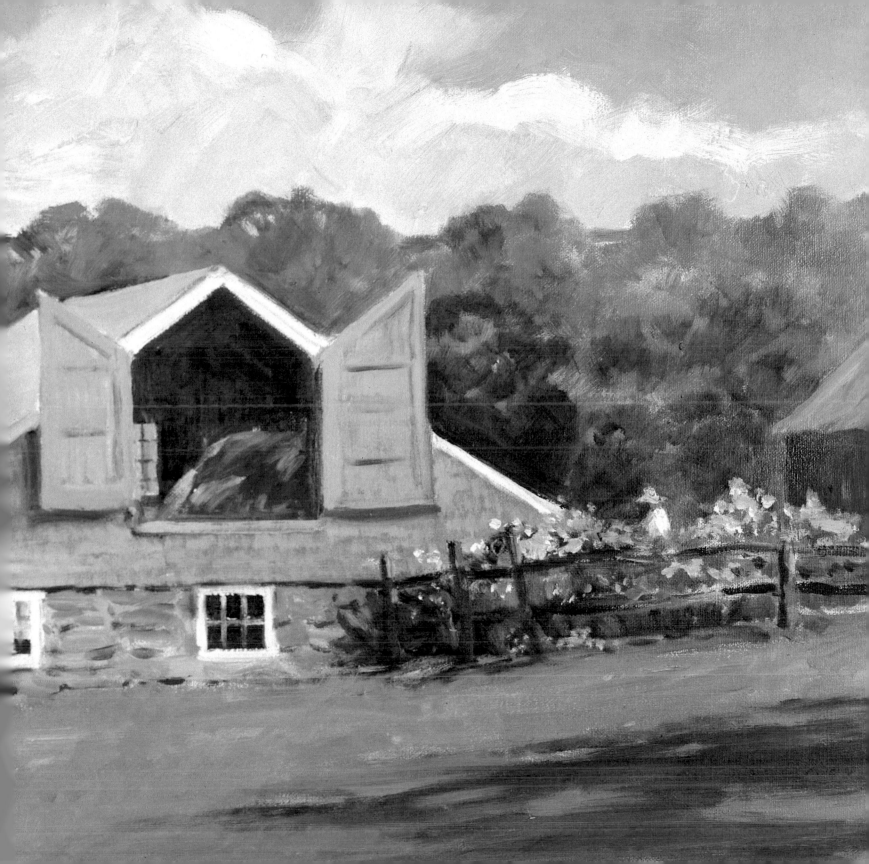

"The Place on the Wayside," he brought a stone and deposited it on a cairn as a tribute to Mayhew. Many, many stones. But in 1901 this haphazard cairn was converted into a formal monument with a bronze plaque and a single boulder with a small, token heap of stones cemented to its back. This seems a pity. If for more than three centuries after Mayhew's death, every passing Indian had deposited a stone, and if the stones were not stolen by souvenir hunters, that cairn might have become one of the world's great rock piles.

Mayhew's missionary work was continued by his father, who preached to the Wampanoags regularly until his death at 92. So many other members of the family joined in this work that they became known as "the Missionary Mayhews." Although the missionary work is now finished, more than 20 Mayhews are still listed in the Vineyard phone book.

The Wicked Sheep Swindle

In the two centuries before the Vineyard became a summer resort, the Island developed slowly. The land was good for grazing and farming, and the ocean was good for fishing. Clearing the land and marking the property lines gave the Island its rich heritage. Small settlements grew up, but this was primarily a rural world, with far more farm animals than people. Sheep-farming was especially successful, with thousands and thousands of sheep grazing over the open lands, providing meat and wool for clothes and export.

The size of the sheep population played an important role in the Vineyard's only incident of note during the American Revolution. Vineyard men have done their duty in all of America's wars, including the Revolution, but they have always fought somewhere else. The Island itself has yet to see a battle of any kind in any war. The nearest thing to it was the infamous Grey's Raid.

Charles Grey was a British major-general who dropped anchor in Vineyard Haven (then called Holmes Hole) on September 10, 1778. According to official report, he was backed up by an armada of 82 sail. Many of these must have been merely tiny support craft, but at any rate, it was a bigger fleet than the citizens dared to challenge.

Grey declared that if the Island's livestock was delivered to him at the dock, he would pay for it. If it was not delivered, he would send his troops ashore to seize it, but then he wouldn't pay anything. The islanders decided they had no choice and duly delivered an extraordinary amount of livestock: more than 300 cattle and *10,000 sheep*. Once this tasty cargo was aboard his ships, Grey said he didn't have the money with him, but the

islanders could collect it from British headquarters in New York. Although repeated efforts were made to collect the debt, it was never paid. You can't trust the British, the islanders said. Perfidious Albion, as Napoleon said.

Wealthy Years of Whaling

During the 19th century, especially between 1820 and the Civil War, the most important industry on the Vineyard was whaling. Long before the settlers arrived, the Wampanoags had hunted whales in small boats offshore, but they were not interested in the blubber, only in the meat. (Remember Moshup's breakfast?) If a dead whale washed ashore, so much the better: meat for everybody, without the trouble and danger of going out after it. When whaling became a serious business, Indians joined the crews, often as harpooners. One of the three harpooners in Melville's *Moby Dick* is Tashtego, a Gay Head Indian. Tashtego has the dramatic final moment of the novel: he is the last man to go down with the *Pequod*, still trying to nail the flag to the tip of the mainmast. Melville's only whaling voyage was aboard an Edgartown ship, the *Acushnet*. He paid tribute to the Vineyard by making the third mate Flask "a native of Tisbury," a man to whom a three years' voyage around Cape Horn was only a "jolly joke."

The Industrial Revolution created a huge demand for whale oil, the best lubricant for all the new machines. It was also widely used for illumination, although a whale oil lamp could be smelly. By the 1800s, the handy offshore whale population had virtually disappeared, so the great whaling ships—from the Vineyard, Nantucket, New Bedford— had to go farther and farther to find whales. If a ship sailed around Cape Horn to the Pacific in search of sperm whales, as many ships did, the voyage could last three or four years.

But it was worth it. The profits from a successful voyage were enormous. Many Vineyard whaling captains retired from the sea with fortunes. Many of the investments that later helped develop the Vineyard came from whaling money, and many of Edgartown's finest old houses—traditionally painted white, with black or very dark green shutters— belonged to wealthy whaling families.

One could profit from whaling without ever going to sea. Edgartown harbor did a brisk business in outfitting and servicing Nantucket's whaling ships. Nantucketers were, it must be admitted, even more famous whalers than the Vineyarders, but a sand bar in

front of the Nantucket harbor entrance made it impossible for a heavily laden ship to sail in or out. As a result, Nantucket ships did their final fitting out and loading up in Edgartown. At the end of the voyage, they unloaded at Edgartown before sailing home. Very profitable for the Vineyard.

The Island's Greatest Entrepreneur

The most successful profiteer of them all was Daniel Fisher, a popular gentleman of great distinction. People who are very rich *and* very well liked are very scarce. Educated at Brown and Harvard, Fisher arrived in Holmes Hole as a young man of 24 to become the Island's outstanding physician and surgeon. The great Daniel Webster was among his patients and came to the Vineyard for medical treatment. But Fisher was far more than a good doctor. He was the best all-around, all-purpose businessman in Vineyard history, easily the wealthiest islander of his century. He was one of those fellows who could not help making money every time he turned around.

It never hurts to marry rich. Fisher picked out Grace Coffin, the daughter of a wealthy Edgartowner, and began looking around for interesting things to do. He invested in practically every Edgartown whaling ship, and since these were still the great days of whaling, he did extremely well. Then, thanks to his involvement in whaling and whale oil, he had a different idea—a spectacularly good one.

All the lighthouses in the United States provided their light from clusters of candles. Dr. Fisher invented a super-size candle made of sperm oil that was bigger and better and brighter than anything around. When he opened a factory in Edgartown to manufacture his sperm candles, the world beat a path to his door. The U.S. government led the way by buying Fisher's candles for all its lighthouses. At its peak his factory, the largest in the country, was turning out 60 tons of candles a year, as well as thousands of barrels of highly refined sperm oil. He was taking in $250,000 a year, a fantastic sum for those times.

What to do next? All the whaling ships used hardtack, a sturdy, unsalted, baked bread that had to hold up through a three-year ocean voyage. Dr. Fisher figured he could probably make hardtack just as well as anybody else, and indeed it turned out that he could. He opened a hardtack bakery in Edgartown and sold his product to the whaling ships (surely including all those ships in which he was an investor). He saw no reason to pay someone

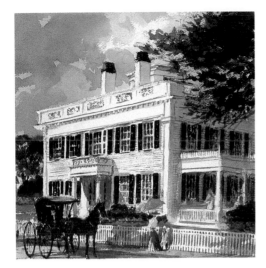

This house on Main Street in Edgartown was built around 1840 and is considered one of the finest examples of the Federal style of architecture on the Island. Owned by the Martha's Vineyard Preservation Trust, the building was the site of the Island's first Designer Showhouse in 1992. I painted it as it might have looked around the turn of the century—the horse and buggy, the little boy in his sailor suit, the lady with her parasol. The original was auctioned for the benefit of the Trust, and the image was used on the cover of the Showhouse booklet.

The Dr. Daniel Fisher House
C. 1992 • WATERCOLOR
12 X 12 IN. (30.5 X 30.5 CM)

else to grind the flour for his hardtack, so he built his own grist mill up-Island. That did well, too. Still finding time on his hands, and not wanting to be idle, Dr. Fisher helped found the Martha's Vineyard Bank and became its first president. He also built the finest house in Edgartown, on Main Street right next to the Methodist Church (known to all as the Old Whaling Church).

A portrait of this brilliant gentleman survives in the Dukes County Historical Society. He is a handsome fellow in his forties with warm coloring, a straight, severe mouth and clear, steady eyes. He has a strong nose with a prominent bridge, no mustache or beard. His tousled, sandy brown hair sticks up like a cockerel's comb, as though alert for the next chance to come along.

Dr. Fisher died in 1876, full of years and riches. His stately white house has been restored and opened to the public by the Martha's Vineyard Preservation Trust, which rents it out for weddings, parties and receptions. Dr. Fisher, a man of public spirit and enterprise, would have approved.

The end of the whaling era was signaled in 1859 when the first oil well was drilled in Pennsylvania. Oil and kerosene from drilled wells were much cheaper and easier to get than whale oil. Whaling ships kept on going to sea for many years, but the great glory days were over. The Vineyard would have to turn to something else.

Fortunately for the Island, that "something else" had already begun.

How to Invent a Summer Resort

How does a place become a summer resort? So many different factors contribute— social, cultural, economic, geographic—and they contribute over such a long period of time that it would seem impossible to select a single, specific starting point. It would seem impossible to say, *Here, right here, on this date and in this place, this is where it all began.* And yet in describing how Martha's Vineyard became a summer resort, we can do precisely that. The date was Monday evening, August 24, 1835. The place was a great grove of stately oak trees. The occasion was the first open-air Methodist camp meeting to be held in what would later become the town of Oak Bluffs.

The Vineyard Methodists did not invent the camp meeting, but they certainly perfected it. With great care they chose the spot, which was rather inaccessible but very

Voices:
A Poet's Century

Dionis Coffin Riggs—poet, author, columnist—has lived on the Vineyard "only" 52 years. But she has spent every single summer of her life on the Island—all 96 of them.

I was born in Edgartown in 1898 and lived there until I was seven. When my father died, my mother had to earn a living, and she decided she could do that better in New York, where my three much older sisters were. She had to leave me behind with my grandparents, James and Mary Cleaveland, in a huge old pre-Revolutionary farmhouse in West Tisbury.

Both my grandfathers and one great-grandfather were whaling captains. James Cleaveland met my grandmother, an Australian girl named Mary Carlin, in Honolulu. He was on his way to the Vineyard from China as captain of the ship *Mary Wilder*. They were married in a week. Later she went on a five-year whaling voyage with him, during which time two children were born in South American ports. My devoted aunt Alvida, who lived in this house while I was growing up, was born in Chile and spent her early childhood on the ship. Henrietta, born two years later in Peru, eventually lived in California. My mother, named Mary Wilder after the ship, was born in this house in 1861.

I went to school in West Tisbury in what is now the town hall. I walked to

Detail of The Barn Cat. *See page 112.*

school each morning, walked home at noon for what we called dinner, then back to school by one o'clock. During the afternoon I looked out the window at the town clock and watched it crawl to four. The last 15 minutes took forever.

My grandfather died when I was still very young, but my grandmother lived on in the house until her death at 89.

When my mother remarried, I joined her and my wonderful stepfather "Daddy Janes" in Brooklyn and later New Jersey. I graduated from teachers college and taught fourth grade for a year before I married Sidney Riggs, a physics teacher and later school principal in New Jersey. We started a family right away with the first of our three daughters.

Because Sid was a teacher, we had those long summer vacations, and we spent them all in my grandmother's house on the Vineyard. Sid loved the Vineyard, too, and devoted his time to making the block prints everyone admired. When he retired in 1954, we moved to the Vineyard for good. Coming to the Vineyard to live permanently was just what we wanted to do, although Sid and I traveled a lot, especially in the winter when this old house is so hard to heat. He died in 1975.

I've lived here ever since in the same old house. I gave two daughters parcels of land on the property, and they built their own houses. The third lives with me. Now we are all here side by side on these 17 acres. We have Boston baked beans together every Saturday night. I have 14 grandchildren, but I always have to stop and count up the great-grandchildren. Right now there are 18.

I started writing poetry after Sid and I married, and I've been doing it ever since. Four of us Vineyard poets published an anthology, and then I've written four books of my own poetry. With Sid's help on research, I also wrote *From Off Island,* a biography of my grandmother in the form of a novel.

I have a small poetry group that meets in my house every other Wednesday afternoon. We read our poems to each other and criticize them. We can all take criticism. We think over the criticism and even use it if we like. We also read other people's poetry. I usually have a *New Yorker* that has just arrived, and I read those poems and we say how awful they are.

I had one of my poems in the *Christian Science Monitor* just recently. It was a good one, too—everybody liked it:

I wonder if the swallows miss
The smell of horse and harness
 leather.
Of sweet white clover in the
 haymow, full warm udders
 ready to be milked,
Of cats, and corn, and brown
 wheat bran.

Detail of To the Barn. *See page 112.*

Gazette. People call me with items, and if I think something interesting is going on, I call them. It's fun, and with a Wednesday deadline every week it keeps me definitely doing some writing. Otherwise I'd just be out in the garden pulling weeds.

I suppose the Vineyard has changed during my century, but things change gradually over the years. If you keep busy, you don't really notice it—except when you try to find a parking place.

Barn Swallows
The old barns on this summer
 island
Are being used for theaters,
For studios, garages, or just
To house the overflow of guests.
The barn swallows have built
 their nests
Over the doorway of the town hall.
I saw them there tonight, asleep.

I wonder if they miss the sound
Of breathing, chewing, snorting,
 nuzzling,
The rustle of a mouse, a cricket
Shrilling; and Grandpa calling back,
"Leave the barn door open just
A little crack—for the swallows."

For the last 18 years I've written the West Tisbury social notes column for the

This unique structure is the focal point of the Oak Bluffs campground and was erected in the late 19th century. It was preceded by a huge tent made of sailcloth that blew down in a violent storm. Made with cast iron supports and designed after a European train station, the tabernacle is one of the great landmarks on the Vineyard.

Tabernacle Concert
1994 • WATERCOLOR
11 X 18½ IN. (27.9 X 47 CM)

beautiful. All through that August week of 1835 they held outdoor meetings where they preached sermons, prayed together, heard each other's confessions and testimonials and accepted new conversions to the faith. Their only "building" was a crude preachers' stand. Both men and women slept on the ground under tents on beds of straw. Since no kitchen existed, the worshippers ate cold provisions they had brought with them. It was primitive but, they all agreed, spiritually uplifting. They promised each other to return next August, and to spread the good word so that others might join them.

Wesleyan Grove, named after the founder of Methodism, became the biggest and best-known camp meeting in the entire United States. Worshippers came not only from nearby Nantucket and New Bedford but from all over New England, and eventually from all over the East Coast. The number of tents grew with the number of worshippers. Oak trees were chopped down to make room for more and more celebrants. In the center of the Grove a great tented tabernacle, large enough to contain benches for

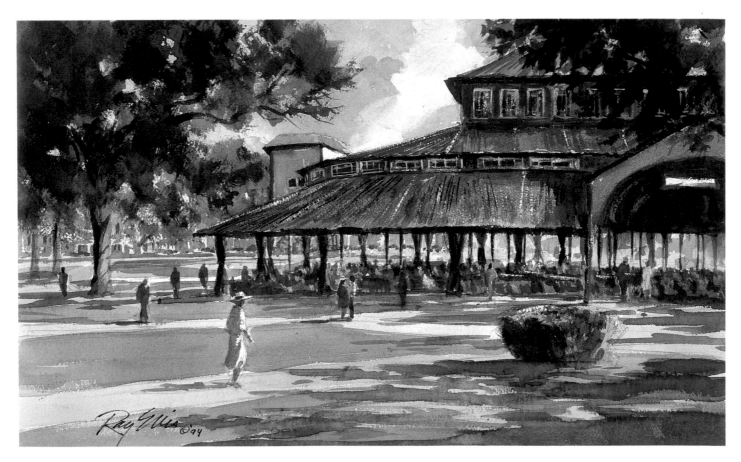

4,000 people, was built to protect the congregations from the hot August sun and summer thunderstorms. (In later years the tent was replaced by an iron tabernacle, still standing today.)

Huge Crowds for "Big Sunday"

Summer after summer the fame of the campground spread. For the last-day climax of the annual meeting, the day known as Big Sunday, steamers brought thousands of excursion customers to witness the event. Crowd estimates were no more accurate back then than they are today, but perhaps 15,000 or 20,000 people attended Big Sunday. The Methodist leaders were understandably upset by this commercialization, for it was plain that not all those people on the steamers were worshippers. They might, in fact, quite properly be called summer visitors. Many were, to use today's term of opprobrium, mere day-trippers, here today and gone today.

In 1859, the same year the first oil well was drilled in Pennsylvania, a Providence worshipper named William Lawton decided that he and his family had spent enough Wesleyan Grove summers living in a leaky tent. He had a little cottage built in Rhode Island, with fancy wooden scrollwork along the eaves, and shipped it over to the Vineyard in sections to be erected in the Grove.

The Finest Gingerbread City Anywhere

There went the neighborhood. Suddenly tents were out, cottages were in. Soon every able-bodied man on the Vineyard who could saw and hammer was building one of these fancy new homes for the Wesleyan Grove regulars. The more ornate the better: gewgaws, scrolls, gimcracks, curlicues, balconies, odd-shaped eaves and windows and railings, often painted in bright colors and sometimes in stripes and whorls and spirals—a true gingerbread city, the finest anywhere. For a time it would be called Cottage City. Fortunately for the Vineyard itself and for all those who visit today, hundreds of these cottages are still there, an architectural delight to the eye and the heart. Edgartown has its quaint old white houses with dark trim, Chilmark and West Tisbury have their traditional Cape Cod shingles, but those who want to see something with truly appealing distinction should walk through the old campground in Oak Bluffs. The oaks are gone, but the houses remain.

In the early 1830s, Methodists from all over the country began coming to Oak Bluffs in the summer for revival meetings. At first they erected tents; by the start of the Civil War, the tents were being replaced by small wooden gingerbread houses. Today the campground (once known as Cottage City) is still a vital part of Vineyard life, and these little homes often pass down from generation to generation.

The Campground · 1993
WATERCOLOR · 10½ × 16 IN.
(26.7 × 40.6 CM)

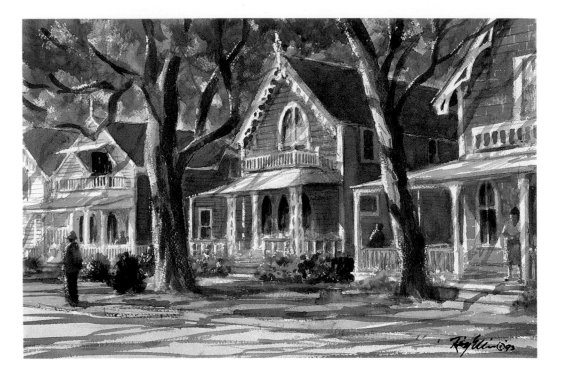

The cottages had more than just a visual impact on the Methodist community. Social ramifications followed. If one owned a cottage, why not come to the Vineyard a few days or a few weeks or even a month before the camp meeting? Why not lend the cottage to relatives or friends? Why not—here is a radical thought—rent it out? There was plenty to enjoy on the Vineyard: sailing, fishing, swimming, surfing, hiking, taking a day-long excursion by boat or carriage to see the stunning Gay Head Cliffs.

Cheating at Croquet

And on top of all that came the croquet craze. Croquet was forbidden in the campground during the week of the meeting, but in the days and weeks before and after, the game was wildly popular and fiercely competitive. In fact, according to a critic, lying and cheating often took place. Even by women! Even by ministers' daughters! The temptation for a woman to improve the lie of her croquet ball beneath the total concealment provided by her long skirt may have been irresistible.

In 1869 a local development group sponsored the first Illumination Night. The cottages and trees were festooned with brightly colored Japanese lanterns, their myriad candles glowing through the darkness. Illumination Night was such a success that it became an instant tradition. Today, more than a century later, the sea of bright lanterns still glows for one night every August.

Between the excursion steamers, the explosion of cottages, the summer diversions and the croquet madness, the Methodist ministers had much to worry about. Everything was becoming too secular, too commercial. They finally built a seven-foot-high picket fence around the campground to protect it from these worldly influences. The charms of commercialization were better appreciated by the Island merchants. With all those thousands of people coming to the Vineyard every summer, surely there must be some dandy ways to cash in on them.

And indeed there were. A land boom swept the Island, or at least swept the more civilized parts. Large tracts were bought and sold by developers and speculators. Advertisements appeared offering unbelievably attractive homesites with spectacular views. A new wharf was built to make it easier to get to and from the Island. Stores and hotels grew up to serve the horde of summer visitors. And, to the wonderment of all, the President of the United States came for a visit. In short, it was all very much like today.

A Visit from President Grant

Ulysses Grant's arrival in August 1874 was memorable because he was the first and, until 1993, only President to vacation on the Island. Never a populist, Grant failed to make the most of this occasion. He did visit the tabernacle, attend a hotel party and see Illumination Night. But he did not seem to enjoy the Island and its people the way he might have. In fact, when he was serenaded one night at his cottage, he came out on the balcony to address the crowd: "I thank you for your cheerful greeting. No doubt you are tired and sleepy, as I am, so I will not detain you. Good night."

These first boom years on the Island are well represented by two major developments, unique to their time. Both came about in the early 1870s. Both were expensive. Both came to a sad end. And both illustrate that combination of imagination, optimism and greed so characteristic of American enterprise.

Nobody had ever seen anything like the Sea View Hotel. It was the brainchild of the

The Real Estate Business

David Flanders of Chilmark has been the leading up-Island real estate figure for 40 years.

My mother Hope really started the up-Island real estate business in 1928. It was mostly summer rentals with just an occasional sale. People—artists, professors—would come for the whole three-month summer with their families and have to pay only $600 or $700.

The first up-Island land boom began after World War II. Before that, land was hard to get. Local people didn't sell land very often. They passed it down in the family to the oldest son or whoever. There wasn't much cash here, so people kept their land and farmed it and passed it along. Tracts were still large. After the war, some people didn't come back, or they decided to do something different, so the land wasn't used so much for farming. More people started to come here from all over the country for vacation, and they wanted to buy land. Local people found they could get what seemed like a lot of money for it. From there on it just escalated.

In those days if people got old or sick and didn't have children to take care of them, the town would take care of them till they died. It was a sort of old-age assistance program. When they died, their land would revert to the town in payment, and the town would sell it off at auction. If a guy lived a long time, the town never got its money back. If he died quickly, the town did all right. That's how many of the oldtimer places went.

I joined my mother full time when I came back from Korea in 1954. I had helped her during previous summers, taking people around, showing them through the houses. She ran the office and did all the bookkeeping. I didn't like the office. I grew up here, I knew all the people, and I liked to be outdoors with them, talking with them and showing land and houses, selling and renting.

The big explosion came in the 1970s, though it started in the late 1960s. Land had been going up all along, up and up the hill, but it wasn't yet wild, it wasn't a frenzy. The explosion was partly due to good times, partly just that the Island was so beautiful. People traveled everywhere, they still do, but they come back here. There's something about the Island, it gets into them and they want to come back.

The building of spec houses started at the end of the 1960s and the early 1970s, but at first it wasn't a big thing. A local man, a contractor, would build one house over the winter in his spare time and figure to sell it. Then they found business was booming, there was money to be made, and they started to go out on a limb, borrowing money to build houses. Land prices kept going up. Even if you didn't build, you could speculate in land and make money. It was crazy. If you bought land, you could be sure it would triple in value in just a couple of years. People would borrow money to buy two or three places at once.

The 1970s was when the Gay Head market collapsed because of the Indians' claim to tribal lands. They filed a Federal lawsuit to get back all the land they said had been stolen from them. Because of the uncertainty about what was going to happen, the banks didn't want to lend money to buy land in Gay Head. You had to use your own money to buy and build there. When lots were selling in Chilmark for $300,000 to $400,000, you could buy the same thing in Gay Head for $125,000, but you had to use your own money, not the bank's money. You also didn't know if the Indians might later lay claim to the land you bought. This uncertainty lasted more than ten years. The Federal government finally decided to grant the Indians the right to some portions of land, and then things gradually improved in Gay Head.

On the Vineyard as a whole, the land market was still working all right as late as 1987–88. We had a pretty good summer. But the recession had already started on the mainland, so I personally stopped buying land, and I started trying to pay off my debts. I was pretty sure something bad was coming.

The end of summer of 1988 was when it happened. It was just like turning off a faucet. Nothing sold. Lots in the woods didn't sell at all. Many people went under, and the banks took their land. But the banks were hurting too, because they had loaned more money than they could sell the land for. It was a real bad time. Chilmark sales held up better than most parts of the Island. Today they are the highest on the Island.

I think it's going to take quite a while, if ever, for things to get back to what they were in the high times. The economy hasn't really come back, hasn't shot up. The best property—waterfront or with a vista—that sells well today, but we're a long way from where we were in the 1980s.

Chilmark is more popular than West Tisbury in spite of the fact that West Tisbury is more convenient to the ferry and the supermarkets and the big shopping towns. Taxes are low on the Island, but they are even lower in Chilmark than in West Tisbury. West Tisbury has so many places inland, sometimes lots of places on one-acre lots. People feel they are in the middle of a housing development.

Chilmark is the best-run town on the Island. For many years we have tried to hold taxes down, and to make sure that

Detail from A Chilmark Pond. *See page 124.*

the money we do spend goes for a good cause. The Community Center, which my mother helped found, was built so that summer renters with small children would have a place for their kids to make friends right away. People come to our Community Center not just from West Tisbury and Gay Head but even from Edgartown.

Also Chilmark is so beautiful. There are a lot of caring people here who want to keep it that way. Conservation started in the late 1950s, early 1960s. It was hard to get people used to the concept, but when they finally saw how good it was to keep the land open, it got a little easier to persuade them.

I care more about conservation than you're supposed to in the real estate business. Maybe it's because I was brought up during an era when there wasn't much going on here. People come back here who've been away a long time—even 30 years— and they say it's developed a lot, sure, but it's still beautiful. Many people are working hard today to keep it that way. Summer people, especially new ones, tell me we ought to have street lights so their kids can walk home in the dark. I really don't want street lights. I walk around here in the winter on the dark roads, and I might see only three or four lighted houses, but I know who they are.

Conservation land goes off the tax rolls, so the town doesn't get any tax money from it, and that does create a problem. But it's worth it. You look at this Island, and you suck it in with your eyes or your nose or whatever. It's beautiful.

Oak Bluffs Land and Wharf Company, a small consortium of wealthy Island sea captains and merchants. The Sea View was the grandest, most imposing structure ever built on the Island. Its location was superb: on the high bluff above the new wharf (also built by the Oak Bluffs Company). Its size was magnificent: five stories high, with 125 rooms, lofty, fanciful towers at each end and a broad wrap-around veranda from which guests could gaze out to sea and watch the arrival of the steamers. The perfect symbol of a summer resort, it opened on the night of July 23, 1872, with an enormous dinner party and endless speeches of self-approval. It lasted 20 glorious years until the night of September 24, 1892, when a fire burned it to the ground. By that time, the first great Vineyard boom was over, and a number of local capitalists were either in debt or bankrupt. The Sea View was never rebuilt.

The Preposterous Vineyard Railroad

The other unique development had a slightly longer but less glorious life, occasionally bordering on the ridiculous. Once upon a time there was a railroad on the Vineyard. It ran all of nine miles from what is now Oak Bluffs to Edgartown and then on to the new beach resort of Katama. Started by the usual little band of captains, bankers and merchants, it was also supported by Edgartown itself, whose citizens voted to invest $15,000 of town funds in the enterprise. In those days the Wesleyan Grove and Cottage City and the little settlement of Eastville and the Sea View Hotel and the Oak Bluffs steamer wharf were all part of Edgartown. Then as now, only year-round residents had the right to vote at town meetings. It could be pointed out, and *was* pointed out by opponents, that the proposed railroad would benefit mainly Edgartown proper and its Katama resort, by enticing summer visitors and their business away from the Oak Bluffs area. But Edgartown proper had the year-round resident votes and got its town investment money and its railroad.

The first grave error was to build the track along the beach, on sandy ground parallel to the Edgartown-Oak Bluffs road. The railroad's founding fathers calculated that this was much cheaper than the longer, steeper route around the back of Sengekontacket Pond. Anyone in recent years who has seen what Hurricane Bob and the Hallowe'en Storm did to the Edgartown-Oak Bluffs beach road could have warned the founding fathers that they were choosing a silly place to lay a railroad track. Indeed, during all the

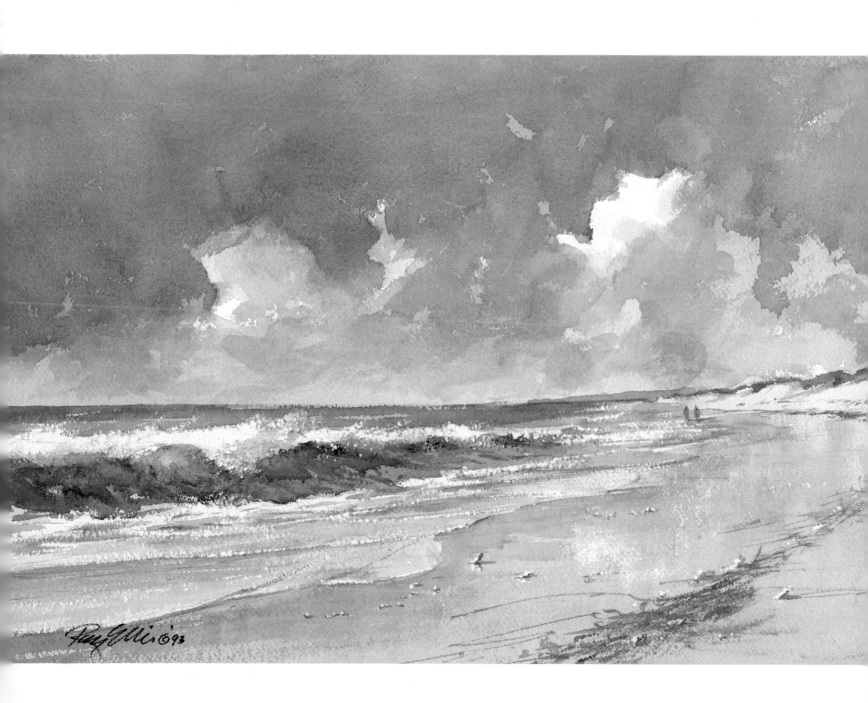

years of the railroad's existence, shifting sands and storms and washouts were a constant and costly problem.

But not the only one. When the locomotive, built in Pittsburgh and christened the *Active,* arrived in Woods Hole on a flat car, a mishap occurred at the railroad siding. Freight cars banged into the flat car from behind and knocked the locomotive off its car and into the harbor, where it sank. With considerable difficulty, the Active had to be hauled out of the water, cleaned up and repaired, then at last shipped by steamer to the Katama wharf.

On August 22, 1874, the train, accompanied by bands and flags and firecrackers, made its first proud run from Katama to Edgartown and along the beach to the Sea View Hotel. At the Sea View an ingenious arrangement of tracks enabled the locomotive to turn around before steaming back to Edgartown.

Despite the fanfare and the justifiable Island pride in having its very own railroad, building costs had run way above estimate, and repair costs to the track damaged by winter storms were high. The first full year of operation was such a financial disappointment that Edgartown voters had to be persuaded not to dump the town's shares of stock on the market.

Finances did improve sufficiently for the Martha's Vineyard Railroad to operate for many years, but always with problems of debt and interest and repairs. When the Sea View burned in 1892, the train lost its turn-around facility. For the last four years of its existence, before service was finally canceled forever, the Active steamed forward to Oak Bluffs but backward to Edgartown.

The Furious "Division" of Edgartown

The arguments over the railroad and its costs added to a movement that had been growing for some years: secession. Many in the Oak Bluffs area felt that the old town of Edgartown was taxing them unfairly and giving back very little in services. Each year the demand for "division" grew louder.

At the town meeting of 1878 the oldtowners voted for a small but politically insane expenditure. They appropriated $500 of town money to fight division. This meant that the secessionists were being taxed for a campaign to fight against themselves. The outcry was furious and the storm increased in fury. At last, two years later, the state legislature bowed to public pressure and divided the two areas into Edgartown and a new town,

Cottage City. That name lasted until 1907, when the townspeople changed to the "nicer" name of Oak Bluffs.

History Disappears in Flames

The citizens of Holmes Hole, in 1871, had also changed their town's name to the "nicer" one of Vineyard Haven. Unlike Edgartown and Oak Bluffs, Vineyard Haven has no gleam of old history in its appearance. That is because its history disappeared in flames on the night of August 11, 1883. The worst fire in Island history started on Main Street in a harness factory, where the Martha's Vineyard National Bank stands today. All of Main Street burned, and the fire spread far beyond downtown, consuming 40 central acres and many businesses and homes. The antique flavor of Vineyard Haven, which was almost as old as Edgartown, vanished with its buildings.

In spite of this dramatic setback, Vineyard Haven quickly rebuilt itself. Four years after the fire it got an additional economic lift when the new resort of West Chop was founded. This community, consisting of grand shingled houses built by wealthy Boston families, lay far out of town near the lighthouse that guards the entrance to Vineyard Haven harbor. In those days this area seemed so isolated that West Chop had its own pier and its own steamer, its own hotel, its own club and tennis courts. It even had its own minute post office, still lovably in use today during the summer season. However, West Choppers did all their shopping in Vineyard Haven, adding to that town's prosperity. Over the years the shoreline between Vineyard Haven and West Chop gradually built up and is now filled with some of the most desirable and costly homes on the Island.

Today Vineyard Haven is the main business center of the Island and has more year-round residents than any other town. Because of the Woods Hole–Vineyard Haven ferry, it is the town most visitors to the Island encounter first. But due to that devastating fire a century ago, this first sight is rather ordinary, far less grand than it might otherwise have been.

Fewer than six months after its worst fire, the Vineyard endured its worst shipwreck. In the pre-dawn hours of January 18, 1884, the luxury steamer *City of Columbus* ran into the boulders of the Devil's Bridge off Gay Head. Passengers and crewmen climbed into the rigging and clung there, hanging on as long as they could. All the next morning in heavy seas and very high winds, Gay Head Indians in small boats did their heroic best to rescue passengers and crew from the wreck, but 121 people lost their lives.

Tinkling Pianos of Music Street

The last decades of the 19th century were a time of many changes in town government and even in town names. Not only was Cottage City separated from Edgartown, but West Tisbury also split off from Vineyard Haven—and for the same reason: high taxes.

West Tisbury drew its name from Tisbury, the township that contains Vineyard Haven. Tisbury was the English parish of the Island's original owner, Thomas Mayhew. The crossroads center of the Island, West Tisbury was mainly a farming community. It did have a commercial enterprise, now Alley's General Store ("Dealers in Almost Everything"), the oldest continuously operating business on the Island. West Tisbury also had its grand old Agricultural Hall, scene of the annual August fair. And it had Music Street, so named because almost every house on it had a piano. On summer evenings one could often hear all the pianos playing at the same time. But the essentially rural nature of West Tisbury is revealed by the fact that Music Street was also known as Cowturd Lane.

The citizens of this farming community saw no reason why they should be taxed to pay for the expensive refinements of Vineyard Haven, such as sidewalks and paved roads. In 1892 they won their independence and became the separate town of West Tisbury.

Chilmark, an up-Island town dating back to 1671, got its name from the English parish of Mayhew's wife. Chilmark is the Island's leading fishing community (*see pages 38–39*, "The Fish Business"). This is thanks to its rich shellfish ponds (oysters, clams, scallops, crabs), its shores (mussels) and its ocean waters (bluefish, striped bass, tuna, swordfish, lobsters). Profitable fishing goes back a long way in Island history. In 1852 when Vineyard fishermen were already selling part of their catch to markets in New Bedford, New York and Boston, they earned four cents a pound wholesale for swordfish. The retail markup raised it to 10 cents a pound. Today it is close to $14 a pound—but still tasty.

Originally Chilmark contained the whole western portion of the Island, but in 1870 Gay Head won its independence as a

Menemsha is one of the true fishing villages left on the Northeast Coast. Many of these shacks on Fishermen's Row replaced those destroyed in the hurricane of 1938. I love to walk my grandchildren through this touch of the past—nets hanging out to dry, lobster buoys piled high, and always the pungent odor of fish.

Fishermen's Row
1993 • WATERCOLOR
15½ x 24 IN. (39.4 X 61 CM)

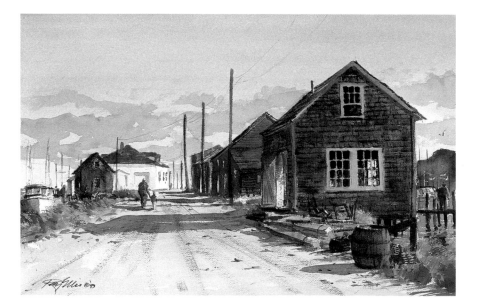

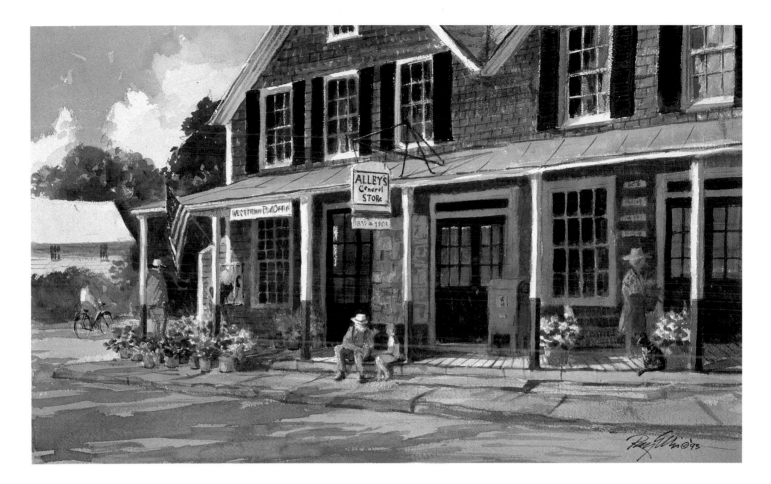

Alley's General Store in West Tisbury, the oldest existing business on the Island, had fallen into disrepair. In December of 1993, the Martha's Vineyard Preservation Trust purchased the store and restored the building. Lambert the Cat is no longer alive, but maybe another will take his place at the front door.

Alley's General Store • 1993
WATERCOLOR • 13¼ X 22 IN.
(33.7 X 55.9 CM)

separate town. The small fishing village of Menemsha, however, which is the Vineyard's most picturesque community, remains part of Chilmark. Gay Head, on the other hand, is almost a separate island to begin with, connected to Chilmark and the rest of the Vineyard only by the narrow strip of land called Stonewall Beach. This strip is, however, quite sturdy, since it consists of more stones than any beach has a right to possess.

Chappaquiddick, a Now-and-Then Island

A similar situation exists on the large peninsula of Chappaquiddick at the southeast corner of the Vineyard. People go back and forth between Chappaquiddick and Edgartown on a tiny but beloved ferry, the *On Time*, but Chappaquiddick is actually connected,

The Fish Business

Everett Poole has been selling fish in Menemsha for more than 50 years.

The first Pooles, a widow with two or three children, arrived here in the early 1700s from Maine. There were cod-fishing stations off Maine before the *Mayflower*. They were catching cod, salting it down and shipping it back to Europe. My mother's family, the Cottles, were here on the Vineyard before the Pooles, so both sides have been around awhile.

They all went whaling, and my great-grandfather was the last one in the family to be a whaleman. My grandfather was a lobsterman and a town fisherman. My father Donald was first a lobsterman, then a swordfisherman and then all kinds of other fish. He finally went back to being a lobsterman at the end because he could go fishing alone and didn't have to have a crew. He told me he got tired of doing all that work for his crew. He fished all his life. The day he died, just a few days short of 80, he had 250 lobster pots in the water.

I started out fishing with my father, but I got in a big argument with him when I was about 13 years old. I didn't realize it, but I guess I had been irritating him all the first part of the summer. We came in from swordfishing one day in early July, and he picked me up by the belt and threw me on the dock, and right behind came my boots and my oilcloths. He said, "Boy, there is no place for relatives on the same boat." I couldn't get another fishing job because all the crews were filled, so I started peddling fish. I bought some fish from the trap fishermen, on credit, and started peddling door to door.

Next year I opened a fish market in half of my father's fishing shack. Once he and I stopped fishing together, we got along fine. The next few years I had the market in several places around the harbor before I built my own market around 40 years ago. I put myself through college at University of Rhode Island, and I spent five years in the Coast Guard, but I always had somebody keep the market going. It was open only in the summer until after I got out of the Coast Guard in 1956.

When I first started, there were quite a few lobstermen. There was also a big swordfish fleet, mostly day boats that came in every evening, although some stayed out four or five days at a time. The boats came from Block Island and Stonington and Point Judith and New Bedford, but during the summer they all fished out of Menemsha. The swordfish in those days used to come up the coast and start finning off Shinnecock, Long Island—the fin comes to the surface so you can harpoon them. They work their way all the way up to Nova Scotia. The boats from here would go down to Long Island in May, and by July 4 they'd be back because by then the swordfish would be off Noman's Land. On a good night we might have 25 or 30 swordfish on the dock.

The Menemsha fishermen made a good living, caught a lot of fish, lots of yellowtail, lots of fluke. Lobsters went way downhill around the late 1950s and early 1960s. At one time only two men were lobstering out of Menemsha, my father and one other man. Then the lobsters came back strong and have been pretty good ever since.

We used to have fish traps—big nets stretched between stakes—that brought in a great variety of fish. When I was first starting in business, I rowed out to them in the morning when they were pulling in their nets and dumping all their fish into a boat. I'd stand on the boat picking out the fish I wanted for my market. In those days the most popular fish was mackerel. The first few years I didn't bother to carry swordfish because there was no local demand for it. Even when I did start, one small swordfish would last me all week. People here just didn't eat it. Most swordfish was shipped to New York. And *nobody* ate tuna.

We sold a lot of fluke. We caught a lot of striped bass, but it wasn't popular because it really doesn't have much flavor. The story around here was that you stuff a bass, eat the stuffing and throw the fish away. But there's always been a huge market in New York for striped bass.

At the market I was selling only to local people. The summer population was very steady, the same people year after year. Mostly Boston brahmins and New York artists and teachers and college professors. In those days the people who came from New York were relatively poor, not like today.

People today cook fish very differently from the way they used to. Most people used to fry their fish or bake it. Now most people put it on a grill, but there were no grills back then. You couldn't have sold a bag of charcoal in all of Chilmark.

Clams, all shellfish, have always been popular, and lobster has always been the most expensive. Most summer people eat lobsters in restaurants rather than at home—it's a messy meal. We only retail about 15 percent of our lobsters. The rest go to restaurants or the mainland.

Swordfish is the most popular for home entertaining, although in recent years tuna is running close. That's tuna for grilling. The sushi craze has peaked. It was very strong a couple of years ago but then took a big dive and is now at a much lower level.

Tastes change a lot. When I first started, the traps were catching very few mackerel and a lot of squeteague. In order

Detail from Cooked Lobsters. *See page 132.*

to get the 30 pounds of mackerel I wanted, I used to have to buy 200 pounds of squeteague at two cents a pound, which I would bring in and give to the lobstermen for bait. I'd keep a couple just in case somebody asked for it. It's a very mild fish, and it used to be popular with people who want something without any flavor. The American public, what they want now is a fish with no bones, no skin and preferably no taste. Then they cover it with tomato sauce and they're happy.

In the early 1960s everybody got into bouillabaisse. That was a big boon for the retail business because you can't make bouillabaisse without spending a lot of money. You have to have a lot of different kinds of fish and shellfish, and even if you buy just a little bit of each one, you run into a lot of expense.

I got into the freezer business because in the wintertime I was getting too much fish to use on the Island but not enough to warrant sending a truck to the mainland. With fish, you've got to sell it or eat it in three days. Freezing helped my business a great deal.

Not everybody eats fish, and not everybody eats it five or six times a week as I do. But people who come here in the summer eat a lot of fish while they're here. Many people who come here for the first time have never eaten really fresh fish before. Overall, we've probably done more to hurt the fish business than to help it. We get people so used to good fish here in the summer that they go home and don't eat it for nine months.

at its southern end, to the mainland. The connector is narrow and fragile, a sand barrier beach at the lower end of Katama Bay. About every 25 years or so this beach erodes away, turning Chappaquiddick into an island. This condition may last as long as a decade, but then the barrier beach restores itself and Chappaquiddick rejoins the mainland. Despite this on-again, off-again physical secession, Chappaquiddick has never separated itself politically from the government of Edgartown. In the winter only about 50 people live there, and some of them don't spend the whole winter. This is not enough bodies to provide selectmen, a planning board, a board of health, a tax collector and all the other personnel that an independent town must have.

Beginning in 1900, another kind of change took place that was neither political nor geographical but social. In that year a black minister, the Reverend Oscar Denniston, came to a church in Oak Bluffs. A small community of blacks had always lived on the Island, but Denniston, a popular and progressive figure, for the first time provided true leadership. During the years of his successful ministry, more and more blacks came to the Island as summer visitors, first from Boston and other New England cities, later from New York. Many were professionals—doctors, lawyers, businessmen, teachers—and many eventually bought homes in the Oak Bluffs Highlands. By the time of Denniston's death, the Island was well on its way to becoming the leading black resort community on the East Coast.

An Explosion of Growth—and Conservation

In our own century two main themes dominate Vineyard history: growth and conservation. These are, of course, in constant conflict. Excessive growth stimulates efforts to preserve what is too valuable to lose. Sometimes the preservation effort is aimed at a single species of wildlife (*see pages 48–49*, "Lose One, Win One"). But the main thrust of the Island conservation movement is to save the land and its beauty.

Since World War II the summer population of the Vineyard has almost doubled and the year-round population has more than doubled. The latter is not because the birth rate ran amok. It is the result of more and more people choosing to live on the Island or to retire there. All these people—summer visitors and year-rounders alike— need places to live. They also need restaurants and supermarkets and drugstores and hardware stores and places to buy clothes and liquor and bicycles and lobsters and

T-shirts. The result has been an explosion of growth, both in houses and in businesses. Much of this is welcome to many people, not only for commercial profit but also for civic pride in the simple fact of growth itself. The precept is as American as blueberry pie: bigger is better.

But thousands and thousands of Vineyarders think not. They think that growth, very especially in waterfront areas and wherever there are scenic vistas, undermines all the qualities that attracted people to the Island in the first place. This is, of course, an old story, by no means unique to the Vineyard. But the Island's response has been unique. It is intense, emotional, imaginative and combative.

Henry Hough, Unlikely Champion

The best representative of this movement is Henry Beetle Hough, the longtime editor and owner of the *Vineyard Gazette*. He was an unlikely champion: slim, bald, soft-spoken, bespectacled, rather shy, with a quiet sense of humor and no sense of bombast. Hough was editor of the *Gazette* for so long—65 years—that many people think he founded it. But the paper, started way back in 1846, was given to Hough and his wife Betty as a wedding present from his father in 1920. With a circulation of only 600, it was not such a grand present, but the Houghs made the most of it. When he died, the summer circulation was 13,000. Betty Hough ran the newsroom, and Henry Hough wrote all the editorials. He became the voice of the Vineyard.

He loved nature, he loved the Island. He admired and emulated Henry David Thoreau, though he was far less cantankerous than the philosopher of Walden Pond. Like Thoreau, Hough was a great walker and an acute observer of the countryside and its changing seasons. His favorite walk was around Sheriff's Meadow Pond, which he owned, but he ranged all over the Island. He walked every day in every kind of weather,

Sheriff's Meadow, a wildlife sanctuary in Edgartown, has a little path that runs around a freshwater pond. Many mornings in every season I can be found walking this circle with our dog 'Toes.' In this watercolor I pictured us making fresh tracks in an early snowfall.

Sheriff's Meadow
1993 • WATERCOLOR
7 X 10 IN. (17.8 X 25.4 CM)

10 to 15 miles a day—at least three hours of walking and often four or five. He also found time to write 24 books, mostly about the Vineyard and the joys of being a *Country Editor* (his first volume). Thanks to his writing, he became a national figure, a rarity among Vineyarders.

The Vineyard counts many writers, past and present, among its celebrities. Internationally famous names abound—Lillian Hellman, John Hersey, David McCullough and William Styron, among others. But they did not earn their fame by writing about the Island, as Hough did.

Artists, too, abound on the Vineyard, for the Island is apparently irresistible as a subject for painters. But only one name closely connected to the Vineyard looms as large as the giant writers: Thomas Hart Benton. A Missourian, he first came to the Vineyard in 1920 and spent many long summers in his converted barn in Chilmark. Until his death in 1975 he painted the Island over and over again, year after year, in his fantastic colors. As he wrote in his autobiography, "Martha's Vineyard had a profound effect on me. . . . I really began to mature my painting."

Pinkletinks and Beetlebungs

Henry Hough, of course, was not a giant, like Benton and the more famous writers. What he wrote about, clearly and often eloquently, was the beauty and wonder of his Island. He marveled at the sound of the pinkletinks, small tree toads that are called spring peepers everywhere but on the Vineyard. He loved the fiery autumn blaze of the beetlebungs, trees that are called tupelos everywhere but on the Vineyard. He was able to convey his delight to his readers, making them realize they lived in a special place. He did not want to see his Island destroyed by haphazard building or by what he called "mainland conformity and blight." There is still no McDonald's on the Vineyard, thanks in large part to his endless opposition.

In 1959 Henry and Betty Hough took the first step in what has since become a major Island program. They created the nonprofit Sheriff's Meadow Foundation and donated to it their 17 acres around Sheriff's Meadow Pond. This was the first Island organization designed, as Hough wrote in the charter, to "Preserve, administer and maintain natural habitats . . . as living museums." Today, thanks to many other individual gifts of land, the Sheriff's Meadow Foundation owns or manages 2,000 conservation acres all over the Island.

From Summer Visitor to Selectman

Edith ("Edo") Potter first came to the Vineyard as a summer visitor more than 60 years ago. For the last 25 years she has lived here year-round.

When my father Charles Welch bought our farm on Chappaquiddick, he asked an oldtimer if the place had a name. Yes, said the oldtimer, it was called Pimpneymouse Farm, *pimpney* being an old Indian word meaning *little*. My father was delighted and had a big sign made. When the oldtimer saw it, he said, "You didn't *believe* me, did you?" But it has been Pimpneymouse ever since.

My father, a well-off sportsman and maverick, bought the farm on Pocha Pond for duck and goose shooting, but he also raised hay and ran a truck garden, delivering milk, eggs, chickens, fruits and vegetables to the summer people. In 1932 he persuaded my mother to leave our home in Marblehead and spend the entire summer on Chappaquiddick. That was when I first came here at the age of five. There were three of us, all girls, with me in the middle.

Chappy was heaven. Most of it was open fields left over from farming days. All the roads were dirt, and kids went everywhere on foot, except for the lucky

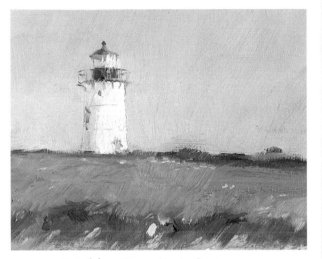

Detail from Pogue Picnic. *See page 92.*

ones who had horses. Houses were few and far between, only about 40 were lived in. My sisters and I explored. We made dams on the creeks. We made playhouses and we "messed around." We started a newspaper called the *Chappaquiddick Weekly*. It was amazing how busy we were.

Of course, we had to help with the farm by picking strawberries and hoeing corn, but those memories fade. What remains is the pleasure we had enjoying this beautiful Island. The beaches were empty with no footprints except our own, and no plastic debris or oil to foul the shoreline. We watched the young deer grow up, the muskrats raise their young, the swallows return to their nests in the barn each year, and all the wonders of a pristine terrain surrounded by warm blue waters and glorious beaches all to ourselves.

When the war came in 1941, we hoarded our gas rationing coupons in Marblehead and saved them for our trip to the Vineyard. During the war there were no summer people on Chappy. My father gave up his truck garden because there were no customers. Instead he grew potatoes—fields and fields of them, all needing hoeing. He sold them to the Navy stationed at the newly built airport.

When my father died in 1946, the farm became just a summer place, although we kept the horses. All of our lives were broadening out, so it is a miracle that the property stayed together. That was thanks to my mother.

The man I married, Bob Potter, became a professor, which meant that he

had summers free. Of course we spent them on Chappy, and our four children were as enthralled with it as we were. We reactivated the farm, with hay and firewood as the main cash crops. Today we have bantam chickens, guinea hens, peacocks, laying hens and a very productive vegetable garden. In 1970 when Bob had a sabbatical, we spent the whole year there. At the end of that wonderful year I couldn't bear to go back to the city. That marvelous tolerant husband of mine was amenable to my commuting back to Providence, where he was teaching at Brown, on a very minimal schedule. All I wanted to do was spend time on Chappy.

I got into politics when the Chappaquiddick homeowners asked Edgartown to increase our zoning from one-acre to three-acre lots. One-acre zoning would have permitted over 3,000 houses, and by the early 1970s the building boom was so strong that we were all concerned about ferry lines and about preserving the rural feeling of Chappy. Since I was going to be there most of the winter, I volunteered to try to persuade the Planning Board to change the by-law.

I met with frustration. I was told they were trying to write a by-law for the whole town, not just for Chappaquiddick. One member worked nights and couldn't attend meetings. One wasn't interested in zoning. One vacancy had not been filled for quite a while. The two other members didn't have time to work on a zoning by-law.

I volunteered to help. I wrote three

Detail from Pogue Picnic. *See page 92.*

towns that I felt would have good zoning by-laws and asked for copies. I then spread them out on my bed and spent long hours cutting and pasting, taking the appropriate phrases from each one and crafting together something that seemed right for Edgartown—and, while I was at it, working in the three-acre lot size for Chappy.

The hardest part was for me, a summer person, to give it to the Planning Board without appearing presumptuous or know-it-all. But the two active members were delighted to have their work done for them. Since I wanted no mention of my part in it, they accepted it and reworked it a bit. It became their own proposal, and miraculously it passed at the town meeting.

The Planning Board was so pleased that they urged the Selectmen to appoint me to the vacancy. I served there from 1973 to 1976 and also served on the Island-wide Martha's Vineyard Commission from 1975 to 1978.

My interest in local politics was whetted the first time I voted in Edgartown. As a summer visitor, I had never had a vote, but now that I was a year-round resident, I did. Being a newcomer to the political life of Edgartown, I was very uncertain about which of two candidates for Selectman was the best. I was undecided right up until I stood in the voting booth. Finally I marked my ballot. The person I voted for won by one vote. It appeared to me that the winning vote must have been mine! What a sense of wonderment that was. I was amazed that one's vote could really matter.

After my three years on the Commission, there was a vacancy on the Board of Selectmen in Edgartown. People had urged me to run before, but I knew that I, an ex-summer person and a woman, could never defeat an incumbent. However, this time the incumbent was moving off-Island, so I had my chance.

Out came that old competitive spirit that has always played a major role in my life. If I was going to run, then I was going to do the best job possible. I worked up a slogan and a card with a photograph and a few appropriate words. I spent every weekend going house to house. I asked the people who came to the door what they would like to see happen in Edgartown and what were their special concerns. The responses were fascinating and most people were eager to talk.

The day of the election I stood on the street all day handing out cards, introducing myself and smiling, smiling, smiling. That night my jaws ached from all the smiling. Because I lived on Chappy, I had to go home on the last ferry at 11:00 and could not stay in the Town Hall for the results. You cannot imagine the euphoria to be called at 1:30 A.M. and be told that I had won.

For the first year I tried to be quiet and absorb as much as I could. Being a woman made it a bit harder. It was difficult for some people to accept ideas from a new Selectman who was not only female but an ex-summer person. I discovered it was better to give my idea quietly in the background, wait for someone to pick it up and then support it as their idea. I also learned to save my fire for what was most important. On the whole, people were extra polite to me. Imagine my delight when one day an old-time politician swore his head off in front of me for the first time. At last he had forgotten that I was a woman!

I served as Selectman for 12 very good years. The townspeople were concerned about what was happening to Edgartown, especially the rampant development, the privatizing of town areas that had always been open to the public and the changes that were happening with breathtaking swiftness. But in 1990 I chose not to run again. I was facing two hip replacements and knew I could not give the job the time it required.

Since then I have given most of my time to conservation and the environment, especially to organizations whose goals are specifically to preserve open space on the Island: the Nature Conservancy, Sheriff's Meadow Foundation, Trustees of Reservations, the Land Bank Commission, the Edgartown Conservation Commission. My goals now are to continue to work to preserve the Vineyard's special places.

It has been extraordinary to have lived here on the Vineyard for 60 years. To have known the Island when it was a quiet, beautiful and fragile place. To have had the opportunity to explore it from one end to the other. And finally, to do something constructive to preserve its beauty. I want my grandchildren to be able to find that same sense of awe and wonder that I did. I want them to appreciate how special it is here, and how lucky we are to have known it.

Many other organizations help preserve the Island against exploitation or badly conceived growth. Some are Island groups: the Vineyard Conservation Society, the Martha's Vineyard Garden Club, the Vineyard Open Land Foundation, the Martha's Vineyard Preservation Trust. The six Island towns also own conservation acres in their own right. Some organizations are state institutions: the Trustees of Reservations, the Land Bank. Some are national: the Audubon Society, the Nature Conservancy. It is not easy to keep all these players straight. Since many of them are supported in whole or in part by private contributions, fund-raising for conservation has become a serious Island industry. Summer people, especially if they are homeowners, are major contributors. Although they cannot vote in local elections and cannot hold local political office, summer people have other ways of giving something back to the Island. Conservation is one of their central interests.

In the quarter-century since the Houghs' 17-acre gift of Sheriff's Meadow, many more acres have been protected. The Vineyard Conservation Society estimates that some 11,000 acres—about 20 percent of the Island—are now under some form of conservation. More land is added every year, although it is never enough to satisfy conservationists. Still, Henry Hough would no doubt have been pleased.

Hough sold his *Gazette* to the Reston family in 1968 after his wife's death, but he stayed on as editor, mainly to write editorials, until the year before his own death in 1985 at the age of 87. Since he was a justifiably sainted figure, it is sacrilege—but true—to say that the *Vineyard Gazette* is a better paper today under Richard and Jody Reston. In both 1990 and 1991 the New England Press Association named the *Gazette* its best community newspaper, the first time any paper had ever won this award two years in a row. It is an award that Hough's *Gazette* never won at all. Hough's greatness was not so much his newspaper, although he published a good one for a very long time, but his vision and his eloquence about the place he loved best.

All-Out War Over Nobnocket

Hough did not live to see the greatest conservation battle in Vineyard history, but there is no question which side he would have chosen. In June 1987, the Martha's Vineyard Commission, a government regulatory body, approved a proposal by the Martha's Vineyard Bank to build a giant new bank, supermarket and parking lot on the outskirts of Vineyard Haven. The complex would be called Nobnocket, the original Indian name

for Vineyard Haven. The Vineyard Conservation Society (VCS) and five other plaintiffs immediately filed suit to block it.

The Island erupted—and went right on erupting month after month, and then year after year. Every conceivable weapon was used by both sides, with passion and power. A partial list of weaponry includes: environmental experts, many lawyers, town meetings, modifications of the proposal, advertisements, traffic studies, environmental impact studies, conflict-of-interest accusations, fund-raising letters, radio appeals, an art auction, door-to-door solicitations, editorials and bumper stickers proclaiming "NObNOcket."

While VCS led the legal battle, virtually every conservation group joined in, as did many other organizations and individuals, especially the townspeople of Vineyard Haven. Summer people joined forces with islanders. Finally, under this enormous cumulative pressure, the bank was forced to give up. Nobnocket will not be built.

A President's Happy Vacation

When Bill Clinton decided to vacation on the Vineyard with his family in August 1993, some islanders were concerned that presidential motorcades, Secret Service agents and the White House press corps would be highly disruptive at the height of the already crowded summer season. But most people seemed pleased that the Clintons had chosen the Vineyard, and thanks to good will on all sides, everybody had a good time. Disruptions were rare and minor. The Clintons spent considerable time by themselves, bothering no one. In private they went crabbing, canoeing and horseback riding along the beach. Like many Island celebrities, they found that it was possible to be yourself, relax, dress any way you like.

The *New York Times* editorial of August 22 therefore came as a shock. Under the headline "Clinton Among the Swells," The *Times* accused the President of deliberately choosing a vacation spot "loaded with policymakers . . . celebrities . . . mainstream millionaires . . . the Washington establishment." The *Times* has always written more accurately and insightfully about places like Bosnia and El Salvador than about places like the Vineyard.

Most people on the Island were offended, and some wrote the *Times* to say so. The *Times* chose to print a temperate letter from Stanley Panitz, a 23-year summer visitor and Chilmark homeowner. The editorial, Panitz said, was "an unfortunate representation of Martha's Vineyard. . . . The Vineyard is not only celebrities. The real island population

Lose One,
Win One:
A Tale of Two Birds

The story of the heath hen is drawn from an unpublished article by the late Maitland Edey, a longtime Vineyarder and bird lover. The story of the osprey is told by Gus Ben David, director of the Felix Neck Wildlife Sanctuary.

A relative of the western prairie chicken, the heath hen was unique because of the male's courting habits, described here by Edey: "As a starter, a bird would appear to grow greatly in size, fluffing out its feathers and lowering its head. Then from the back of its neck would rise two feathery tufts which were held straight up like a pair of large rabbit ears. Next its tail would be raised and spread into a fan, and its wing feathers spread also. In this bizarre attitude the bird would begin running and strutting around, sometimes backwards and forwards, sometimes in circles. Often with a loud cackle it would jump straight up in the air. . . . Most remarkable of all was the 'tooting' or 'booming' which accompanied this display. It was a slow *woo-woo*

or *woo-doo-woo*, all on the same pitch and sounding as if somebody were blowing across the neck of an empty bottle. . . . This extraordinary noise was produced by inflating a pair of bright orange air sacs in the sides of its neck. These were generally round and when fully inflated were as big as tennis balls."

Although obviously a champion at sexual display, the heath hen had two major drawbacks: it was good to eat and easy to shoot. Originally the bird's habitat was bushy plains all across the northeastern U.S., but as settlements and towns grew up in the 19th century, this habitat shrank to fewer and smaller areas. At the same time, the increasing population both of human hunters and of dogs and cats reduced the heath hen's numbers to zero in state after state. By the end of the 19th century the bird survived in only one place: the central plains of Martha's Vineyard.

Bird lovers and nature organizations and state legislators set out to help the heath hen win its last stand. In 1907 a huge preserve of 1,000 acres (what is today the State Forest near the airport) was established in the center of the Island to protect the bird. A warden was hired to guard against poachers, feed was set out, a campaign was mounted against hawks and cats, a fire tower was built and fire breaks were cut to protect the birds, especially during nesting season. Thanks

to these and other efforts, the population rose from a low of 50 birds all the way up to 2,000 in 1916. Conservationists had every reason to feel confident.

But that spring during the nesting season, a simultaneous gale and forest fire swept through the preserve. Because of the high winds the flames leapt across the fire breaks. This killed many, many birds and wiped out 20 square miles of their habitat.

The heath hen never recovered. In 1921 only 117 birds were left. By 1928 only three remained—all males. No female was left to witness a courtship display or to lay a final batch of eggs. The fight was lost. The last heath hen in the world was seen for the last time at a West Tisbury farm on March 11, 1932.

Gus Ben David's Story of the Osprey Is More Cheering

The Vineyard never used to have a large population of ospreys. During the 1920s, 1930s and 1940s there were never more than four or five nesting pairs at one time. They like to nest in dead trees near the ocean, and on the Vineyard there are very few such trees. During the 1930s and 1940s when power lines were brought in to the properties along the south shore of the Island, ospreys nested on the poles.

They were trying to expand their population here. But the electric company had to knock down these nests because they were a fire hazard.

In 1969 I became director of the 350-acre Felix Neck Wildlife Sanctuary on the edge of Sengekontacket Pond. Only two osprey nesting pairs were on the Vineyard. One was in an old tree on Priester Pond in West Tisbury, the other was in a dead pine at Mink Meadows in Vineyard Haven. When the pine tree blew over, I put up an old telephone pole and built a platform on top of it. It worked. Ospreys nested on it.

I've always had an innate fondness for birds of prey—eagles, hawks, ospreys—and to me the ospreys really personify the Vineyard. They are wonderful birds, so beautiful and so dramatic. I wanted to attract more of them, so over the years, with the very generous help and partnership of the Commonwealth Electric Company, I've put up more and more poles and platforms. The ospreys build their own nests, using our platforms. In August 1991, Hurricane Bob blew down all the nests, but we didn't lose a single pole. And because the young birds had just fledged and could take cover on the ground, we didn't lose any birds, either.

People all over the Island now come to us and ask if they can have an osprey pole. If the place is right for the birds and not too close to another nesting site, we build one. It costs about $600 to put up a

Detail from The Osprey Nest. *See page 126.*

new pole and platform. The program has been a great, great success. In 1993 we had 75 nesting pairs on the Island!

And those birds will all come back, because ospreys have what we call "nest-site fidelity." When the birds are old enough to breed, in their second or third summer, they come back from their winters in South America to the place where they were born. They can't use their original nest because their parents still own that and will defend it against all interlopers. So the young birds, driven away from their original home, try to find a nesting place somewhere in the general area. Once they pick a nest site, they return to it every year. We have one banded male osprey at Felix Neck who just returned for his 17th consecutive summer—a true Vineyard summer person. Ospreys are even more faithful to their nest site than they are to each other. If one mate dies, the other will find a new mate but will continue to use the old nest site.

March is an exciting time for me, because that's when the ospreys return to the Island. The male always arrives first, usually the third week of March, and the female comes soon afterward. They rebuild their nest, raise their family, teach the young birds to fly and to hunt. Then they all leave the first week of September, just like most other summer people.

consists of fishermen, farmers, tradespeople and professionals, with large numbers of seasonal visitors, who come to enjoy its natural beauty and solitude . . ."

The *Vineyard Gazette* was much more accurate than the *Times*. As one headline put it, "A Perfect Match: Family and Island Get It Just Right." As the *Gazette* also said, "The President and his party mixed comfortably not only with Vineyard celebrities but with average summer folk along the main streets of Island villages, with crowds at the annual county fair, with local shopkeepers and public gatherings at restaurants. The Clinton visit struck just the right balance between the rich and the rest, a balance that in the end drew the appreciation of all."

When the Clintons got back to the White House, they sent a letter "To the People of Martha's Vineyard," thanking them "for the overwhelming hospitality" and "for allowing the three of us to share your wonderful island . . . (and) the beauty of this special place."

Vineyarders have known their Island's virtues all along, but they were pleased that the President of the United States had learned it in one short visit. They were also pleased that he, like most visitors, enjoyed the Vineyard so much that he returned for a second vacation the following summer. Perhaps during his second visit he learned that the correct word is Island, with a capital *I*.

"Exceeding Good and Very Great"

The first man ever to write about the Vineyard also called it "island," with a small *i*. No matter. His enthusiasm, excitement and sense of wonder still shine through the old Elizabethan wording and spelling. He was John Brereton, the chronicler of Bartholomew Gosnold's voyage of discovery in the tiny, 32-man ship, *Concord*. Here is what Brereton wrote about the Vineyard in that far-distant month of May, 1602:

> "On the outsides of this island are many plain places of grass, abundance of strawberries and other berries. . . . In mid May we did sow in this island in sundry places, wheat, barley, oats and pease, which in fourteen days were sprung up nine inches and more. . . . The soil is fat and lusty. . . .
>
> "This island is full of high timbered oaks, their leaves thrice so broad as ours; cedars, straight and tall; beech, elm, holly, walnut trees in abundance . . . hazlenut trees, cherry trees . . . sassafras trees, great plenty all the island over, a tree of

The cove at Lobsterville in Gay Head looks back into Menemsha Pond toward the Coast Guard Station. There are various beached boats in the cove, some of which have long been abandoned. This white overturned one appeared to be nesting in the rugosa roses.

Lobsterville Beach • 1993
WATERCOLOR • 10 X 15 IN.
(25.4 X 38.1 CM)

high price and profit; also divers other fruit trees, some of them with strange barks of an orange color, in feeling soft and smooth like velvet. . . .

"On the northwest side of this island, near to the sea-side, is a standing lake of fresh water, almost three English miles in compass. . . . This lake is full of small tortoises, and exceedingly frequented with all sorts of fowls . . . whose young ones of all sorts we took and eat at our pleasure . . .

"Also divers sorts of shell-fish, as scallops, muscles, cockles, lobsters, crabs, oysters, and wilks, exceeding good and very great . . ."

It all sounds quite wonderful. And what John Brereton wrote about the "shell-fish" could be said, four centuries later, about the entire Island: "exceeding good and very great."

Edgartown

Oldest town on the Vineyard and very proud of it . . . Proud of its white frame houses with pitch-dark shutters . . . A great whaling center last century, when many sea captains built fortunes from the oil they bravely harvested all over the world . . . A town of white picket fences and well-kept gardens and always, always, the sight and sound of the ocean.

In order to sketch this view of our church with Edgartown Harbor and Chappaquiddick beyond, I went up in a cherry picker. A newspaper account of this feat reported that I had gone up in a cranberry picker! I painted this to commemorate the 350th anniversary of the founding of this congregation. The original hangs in the rear of the meeting house.

Federated Church · 1991 · WATERCOLOR · 19 X 25 IN. (48.3 X 63.5 CM)

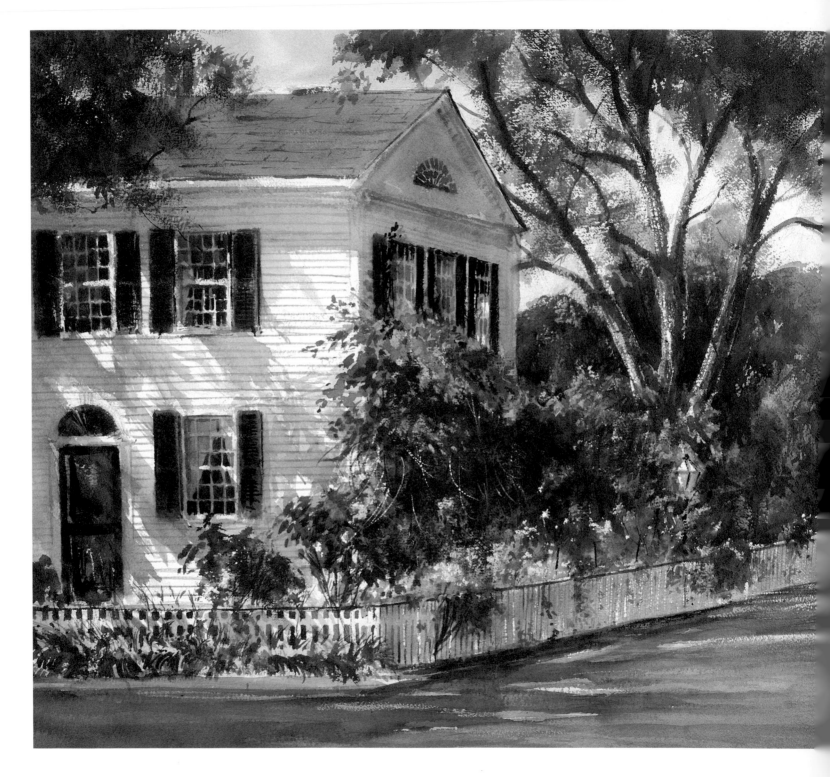

ined with beautiful colonial homes and gardens, this lane is usually very
quiet even during the summer months.

Down Davis Lane • 1984 • WATERCOLOR • 21 X 29 IN. (53.3 X 73.7 CM)

The simplest subjects can sometimes be the most interesting.
Back doors are probably used more often than front ones on the Vineyard.

The Back Door • 1987 • WATERCOLOR • 16¾ X 21½ IN. (42.5 X 54.6 CM)

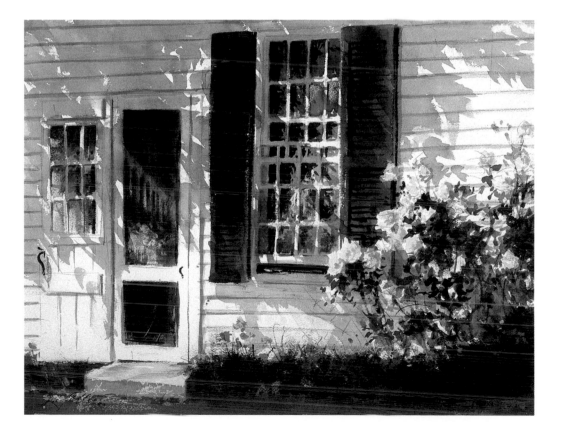

Off South Water Street in Edgartown, there is a lovely tidal marsh that fills at high tide. In the 1970s, a vegetable garden was maintained just above the shoreline. I passed this scene many mornings on my bike on my way for a newspaper. One morning I finally set up my easel and painted it.

Garden by the Marsh · 1978 · OIL · 16 X 20 IN. (40.6 X 50.8 CM)

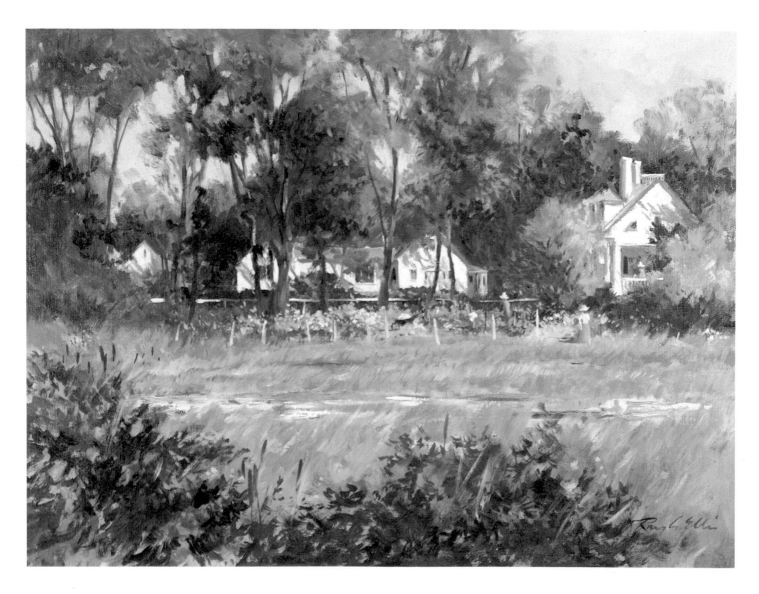

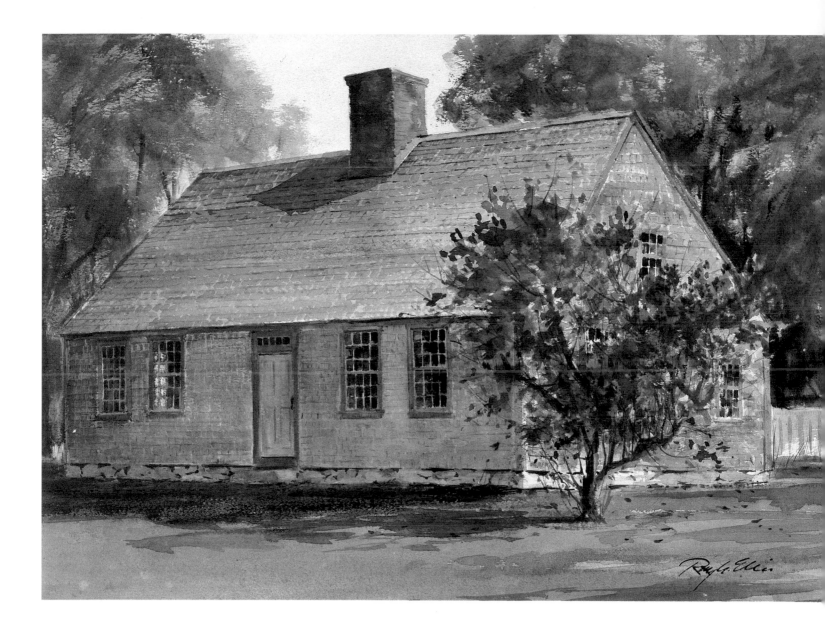

I painted this house in 1978 shortly after it was moved from the Great Plains to its present location behind the Old Whaling Church in Edgartown. Reputed to be the oldest house on the Island, it is owned by the Martha's Vineyard Preservation Trust and is open to the public as a museum during the summer season.

The Vincent House • 1978 • WATERCOLOR • 18 X 29 IN. (45.7 X 73.7 CM)

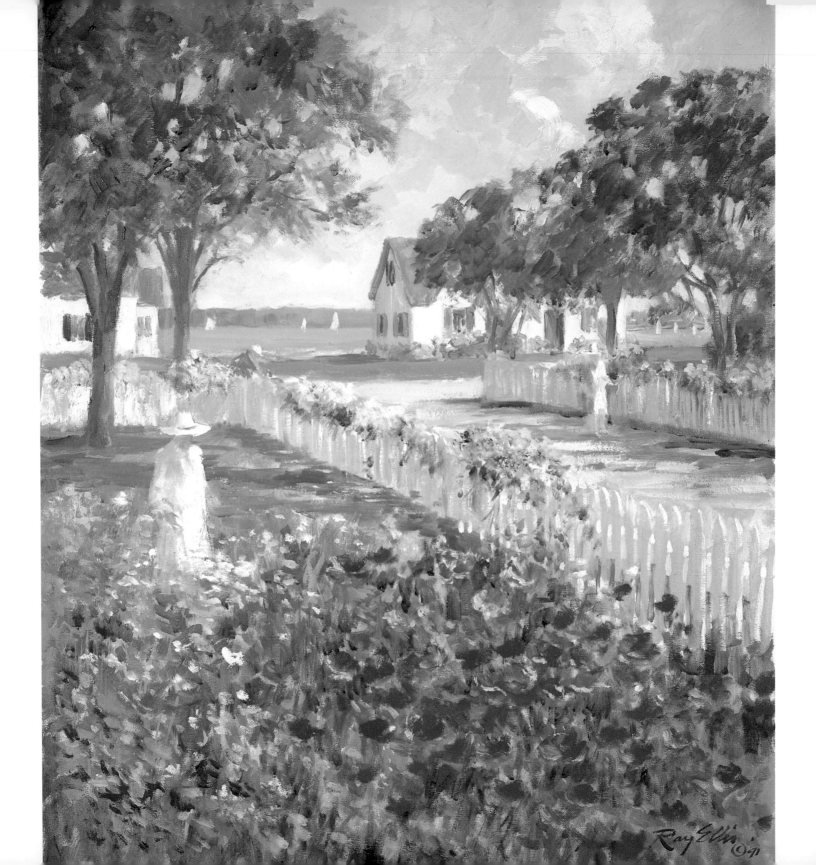

Ray Ellis ©91

When I think of the Vineyard, I think of sailboats, white picket fences crowned with roses, and colorful perennial gardens. This painting celebrates them all.

Harbor Garden · 1991 · OIL · 23 X 17 IN. (58.4 X 43.2 CM)

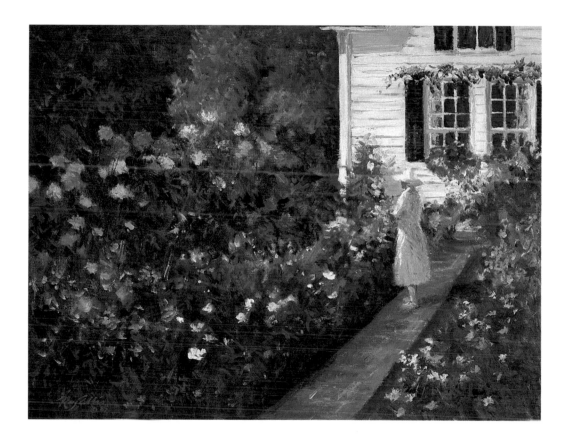

Emily Post lived in Edgartown for many years in this house, and her family continues to live there today. Along the brick path to the front door are the most beautiful dahlias I have ever seen. The borders are filled with colorful annuals and perennials. When most Island gardens are past their prime, this one looks as fresh as it did in early summer.

Emily's Garden · 1987 · OIL · 12 X 16 IN. (30.5 X 40.6 CM)

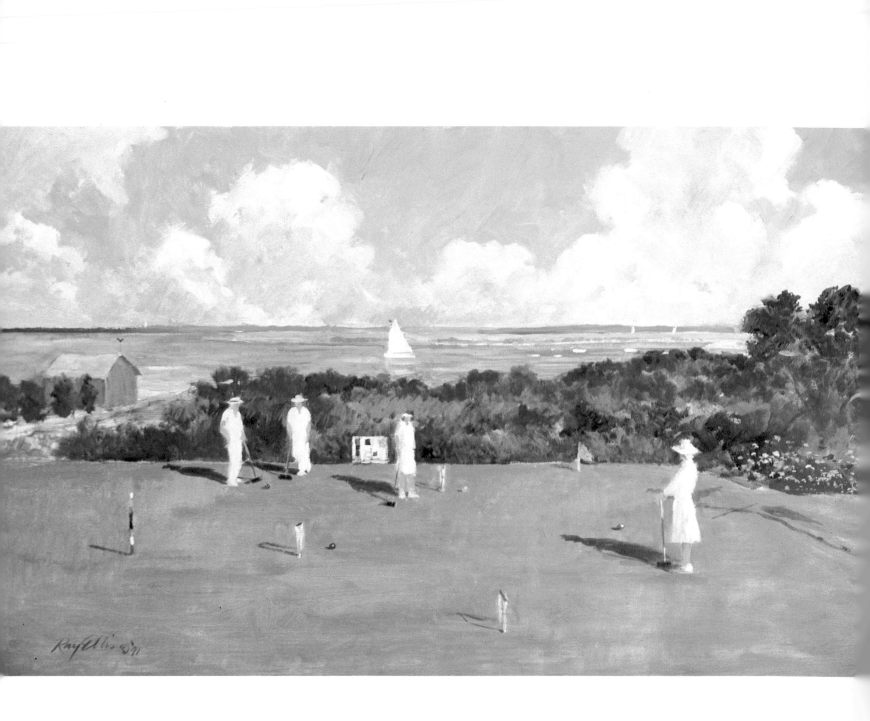

One of the most spectacular vistas from a croquet court must be that of our friends on Eel Pond. On Sunday afternoons in the summer, spectators and players in their whites gather for a match. The setting reminded me of subjects I had seen painted by Homer and William Merritt Chase. When my friends asked me to paint this scene for their collection, I was thrilled.

Croquet at Eel Pond · 1991 · OIL · 20 X 36 IN. (50.8 X 91.4 CM)

Hundreds of enthusiastic and promising young tennis players follow their professional teachers to the court at many locations on the Island.

Morning Lesson · 1994 · OIL · 15 X 30 IN. (38.1 X 76.2 CM)

My friend Henry has created a beautiful English perennial garden on a pond looking out toward the sea. I will never know how he achieves such perfection summer after summer when the garden faces the prevailing winds, and the elements are often unkind.

Henry's Garden • 1991 • OIL • 20 X 30 IN. (50.8 X 76.2 CM)

Sitting right on Edgartown Harbor is a fine example of a formal parterre garden. Since it is not visible from the street, I was delighted to be invited to come on the property to paint it. I chose this elevated view from the porch of the house to show the geometric layout. Some years ago, seawater from Hurricane Bob covered the garden, but it somehow continues to flourish in spite of its proximity to water and wind.

Parterre Garden • 1991 • WATERCOLOR • 18 X 28 IN. (45.7 X 71.1 CM)

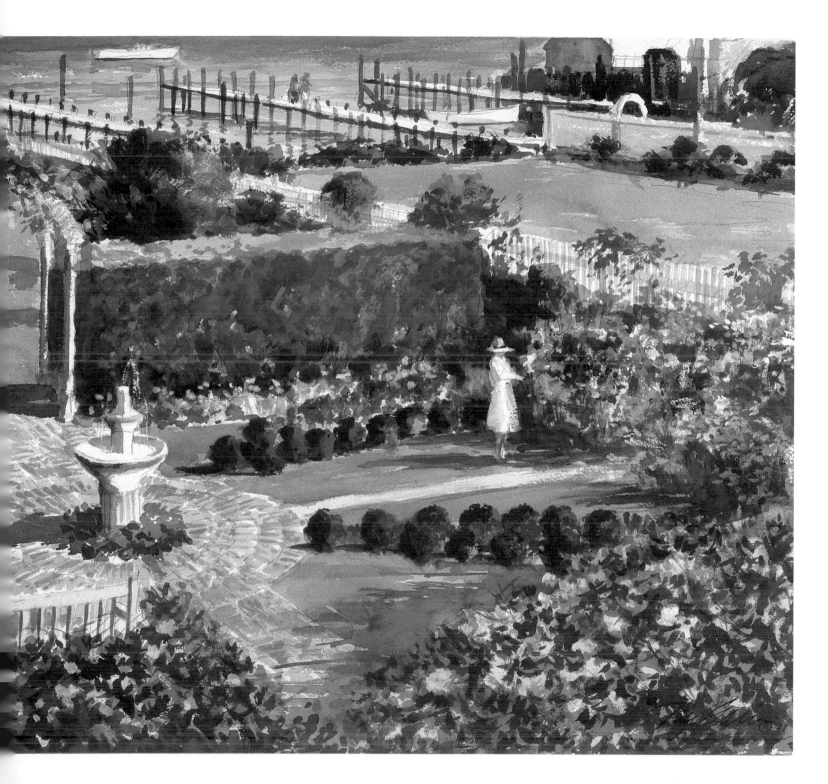

Each summer I get a call from friends up the road who let me know that the butterfly weed is at its peak in front of their old saltbox. It's a call I look forward to—nothing brightens up a meadow like this beautiful orange weed.

Butterfly Weed · 1988 · OIL · 24 X 40 IN. (61 X 101.6 CM)

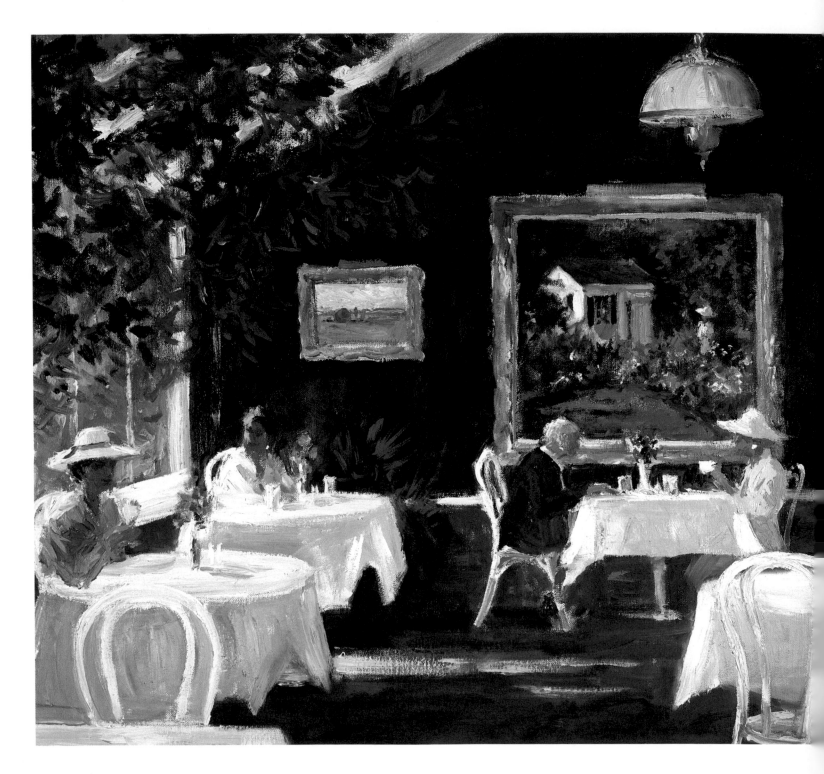

Queen Anne's lace, wild asters and many other wildflowers abound on the Vineyard. These arrangements are likely to adorn many homes in the summer.

Wildflower Still Life • 1981 • WATERCOLOR • 19 X 28 IN. (48.3 X 71.1 CM)

For a special treat on a Sunday morning, my wife and I leave church and walk a few steps to Edgartown's Charlotte Inn for brunch at L'Etoile. This room reminds me so much of some of the dining scenes of my favorite Impressionists—the bright light from the courtyard through the windows, the dark green walls, stark white tablecloths and, always, fresh flowers on the tables.

Brunch at L'Etoile • 1987 • OIL • 20 X 30 IN. (50.8 X 76.2 CM)

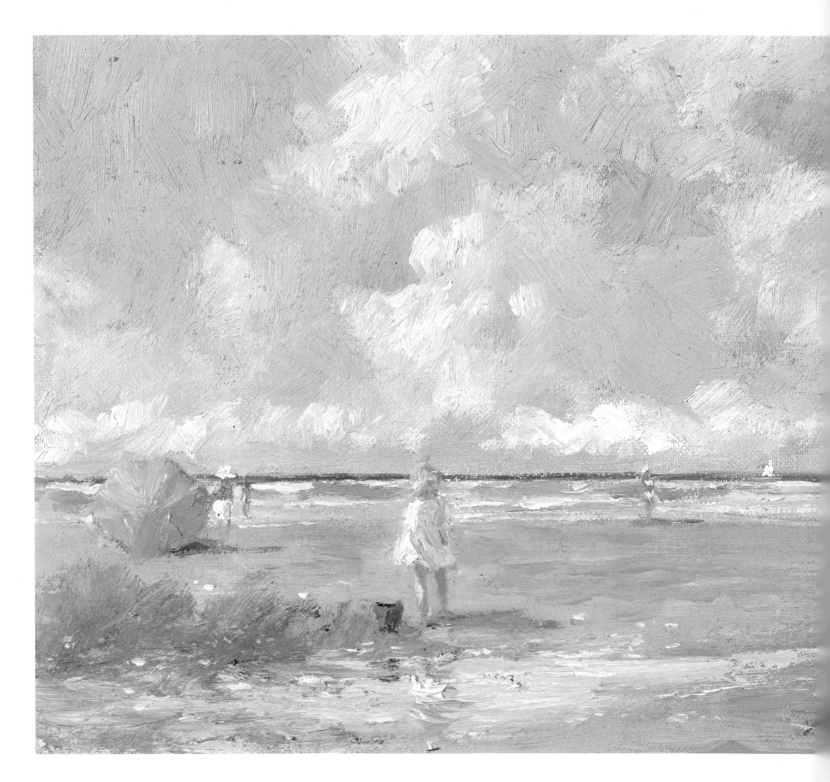

This is a familiar scene and also a ritual on a hot summer Sunday.

Sunday Paper • 1984 • WATERCOLOR • 8 X 11 IN. (20.3 X 27.9 CM)

I spotted this little girl with her blue pail playing by a tidal pool. I painted this scene with the hope of capturing her sheer delight in such a simple pursuit.

The Blue Pail • 1986 • OIL • 7 X 9 IN. (17.8 X 22.9 CM)

This little mudhole is between Sheriff's Pond and Eel Pond and is surrounded by cattails in the fall.

Fall—Butler's Pond · 1994 · OIL · 8 X 10 IN. (20.3 X 25.4 CM)

Morninglory Farm outside Edgartown is open from May to Thanksgiving. In spring we fill our car with herbs, annuals and perennials for our garden; in summer with their home-grown produce. But pumpkin time at the farm is my favorite—a cacophony of oranges, yellows and browns and the smell of wood smoke from the stove inside. To me, it heralds the end of another busy summer season and the beginning of quiet renewal.

Pumpkin Time · 1986 · WATERCOLOR · 16 ½ X 24 IN. (41.9 X 61 CM)

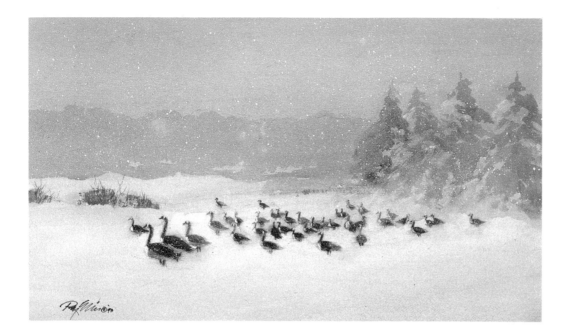

During a particularly beautiful winter storm, a flock of Canada geese descended on a snow-covered cornfield near Morninglory Farm outside Edgartown. They huddled close together, silhouetting themselves against the wind-driven snow.

The Gathering • 1993 • WATERCOLOR • 14 X 24½ IN. (35.6 X 62.2 CM)

I passed by this old boathouse one winter day. I loved the composition, with the snow almost covering a lobster trap, but I wanted a touch of color. I put geraniums in the windows, a sight common in Vineyard houses in the winter and used this painting for a Christmas card.

Winter Geraniums • 1985 • WATERCOLOR • 9 X 11 IN. (22.9 X 27.9 CM)

On Island Waters

Dotting every bay and pond and lagoon and stretch of ocean, the Vineyard's varied armada of catboats, sloops, yawls, ketches, schooners, dinghies, dories and, come winter, the scallopers.

Any evening during the summer there is much activity in the harbor. Launches going to and fro. Magnificent yachts entering past Edgartown light. Fishermen bringing home their catch.

Harbor Evening · 1990 · OIL · 24 X 40 IN. (61 X 101.6 CM)

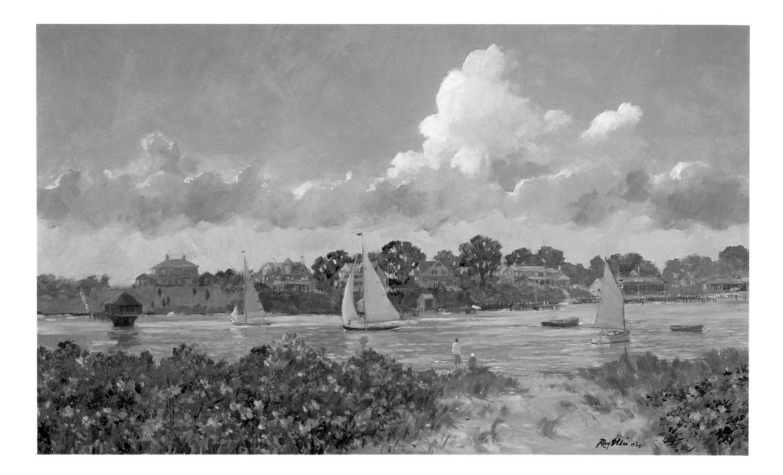

I have done several paintings from Chappy. This one pleased me as I tried to capture the afterglow on the harbor. The last house on the right was where my studio once was.

Twilight—Tower Hill · 1993 · OIL · 36 x 60 IN. (91.4 X 152.4 CM)

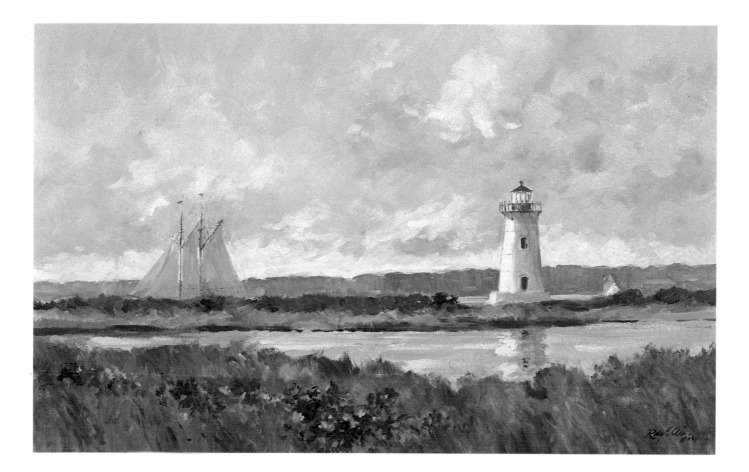

How fortunate I was to be walking up North Water Street when a schooner was just passing Edgartown Light—the early morning sky in many shades of blue and lavender, the lighthouse reflected in the inner pond, the sails silhouetted against the background. I walked home as quickly as I could and painted this from memory.

Morning Passage • 1989 • OIL • 24 X 40 IN. (61 X 101.6 CM)

ew work harder to earn a living than scallopers, particularly in the winter, and there are quite a few of them on the Vineyard. Bay scallops are still one of the favorite delicacies on any menu.

Winter Scalloper · 1993 · OIL · 9 X 12 IN. (22.9 X 30.5 CM)

ach July catboats from all over New England rendezvous in Edgartown for the annual Regatta. Rafting catboats at the end of the race is part of the weekend's rituals, as friends relive experiences over a drink.

Catboat Rendezvous · 1989 · WATERCOLOR · 10 X 24 IN. (25.4 X 61 CM)

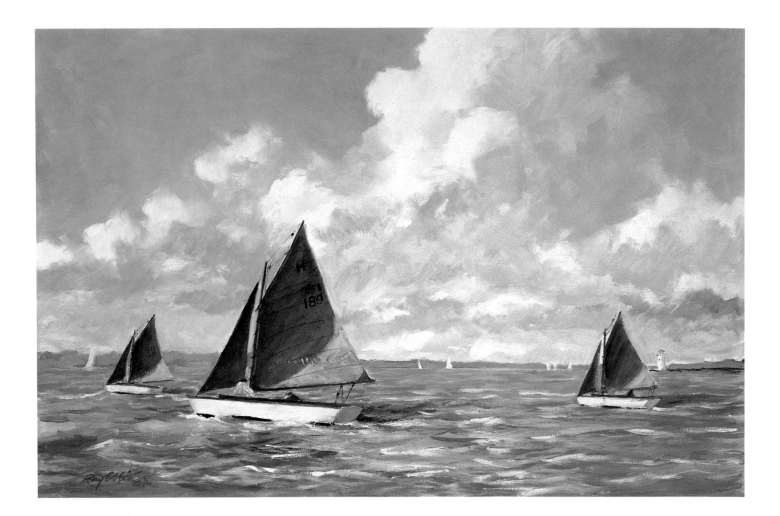

These brown-sailed little gaff-rigged sloops are a very popular class on the Island.

Herreshoff's Racing • 1990 • OIL • 24 X 36 IN. (61 X 91.4 CM)

Once a year catboats arrive from all over New England to sail in the Edgartown Catboat Regatta. The race is preceded by a parade of as many as thirty catboats sailing by the Yacht Club and municipal wharf.

Catboat Regatta · 1989 · OIL · 11 X 14 IN. (27.9 X 35.6 CM)

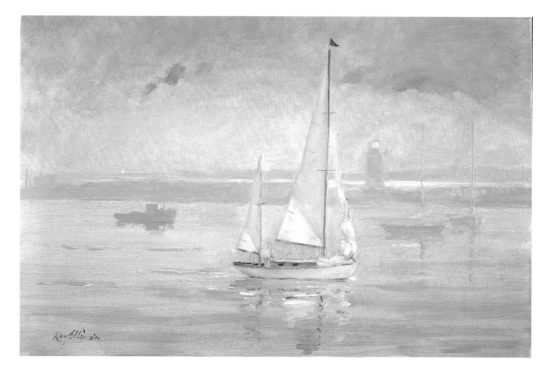

Fog is part of island life, and we do have our share. In this painting a lone yawl slips by Edgartown light and several moored boats into the safety of the harbor.

In From the Fog • 1993 • OIL • 24 X 36 IN. (61 X 91.4 CM)

A Shields has, to me, the most beautiful lines of any sailboat. I watched a race one day in Nantucket Sound and immediately came home and painted this in my studio. I particularly liked the composition, with the angles of the masts against the horizon.

Shields Racing • 1988 • OIL • 11 X 14 IN. (27.9 X 35.6 CM)

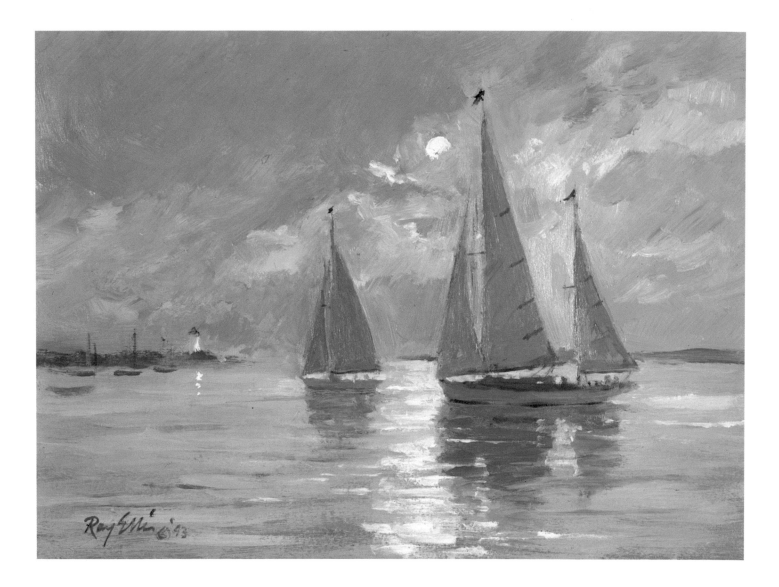

Few sights are equalled when a group of sailboats glide out
past the light on a bright moonlit night.

Moonlight Sail • 1993 • OIL • 11 X 14 IN. (27.9 X 35.6 CM)

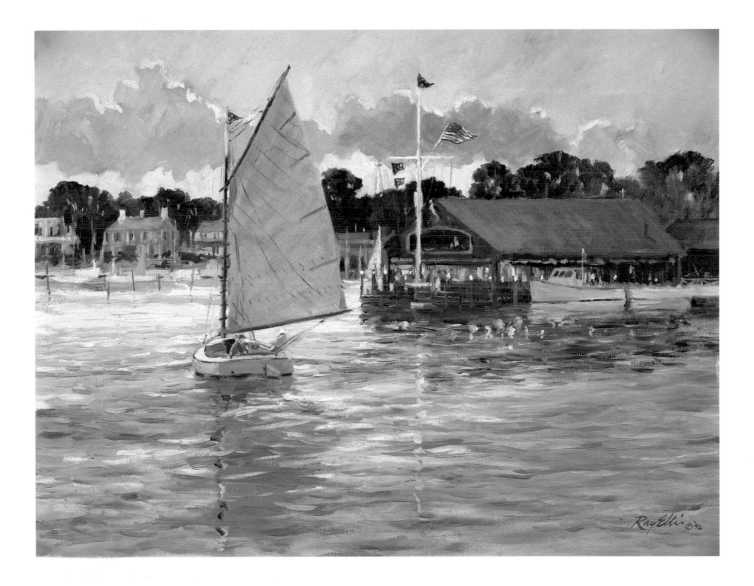

Late on summer evenings, a parade of boats returns to Edgartown Harbor, past the lights of the Yacht Club. At sundown a cannon fires, and flags are lowered from the yardarm signaling the end of another day.

Time for Colors · 1992 · OIL · 22 X 30 IN. (55.9 X 76.2 CM)

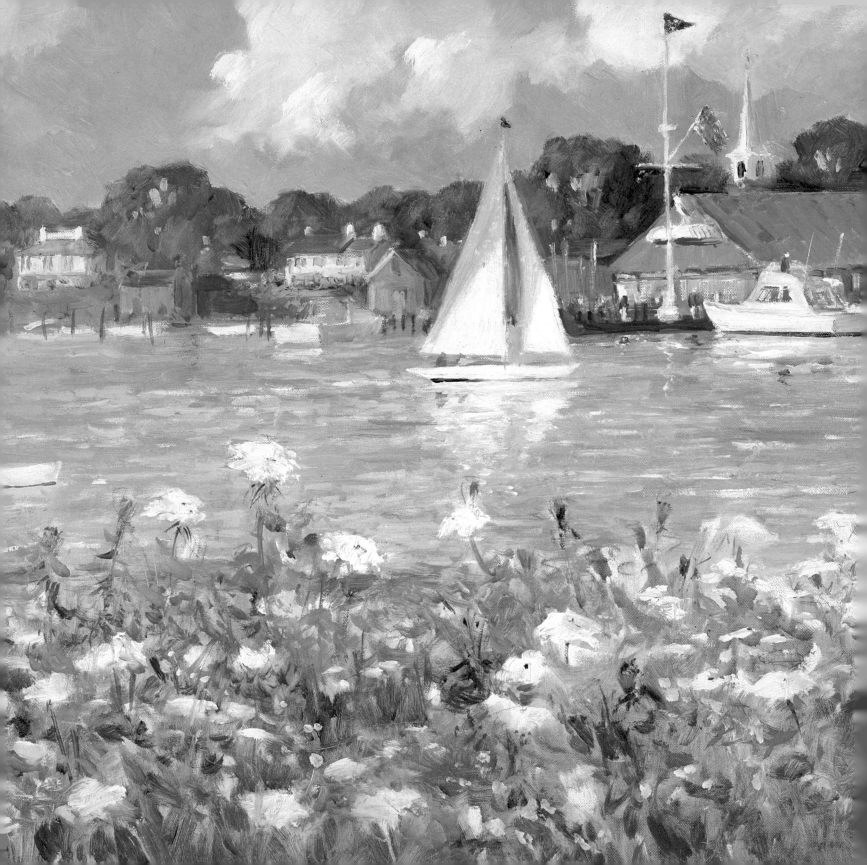

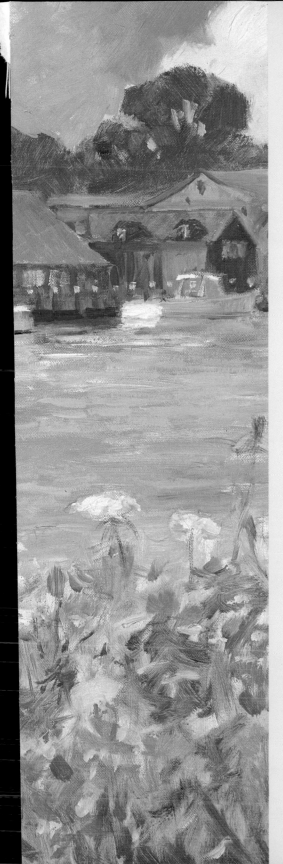

Chappaquiddick and Katama Bay

Chappy, the most remote, lonely and, in the opinion of every Chappy resident, beautiful part of the Vineyard . . . Sometimes connected to the Vineyard, sometimes severed by the ocean into a separate island . . . Long sandy beaches sprinkled by day with beach umbrellas, by night with fishermen casting for stripers . . . Between Chappy and Edgartown, the broad waters of Katama Bay, home to a thousand sailors.

If you get low enough in a field of wildflowers, they make a wonderful foreground for the view across the harbor. In this case the flowers are Queen Anne's lace.

From Chappy Shores · 1994 · OIL · 15 X 30 IN. (38.1 X 76.2 CM)

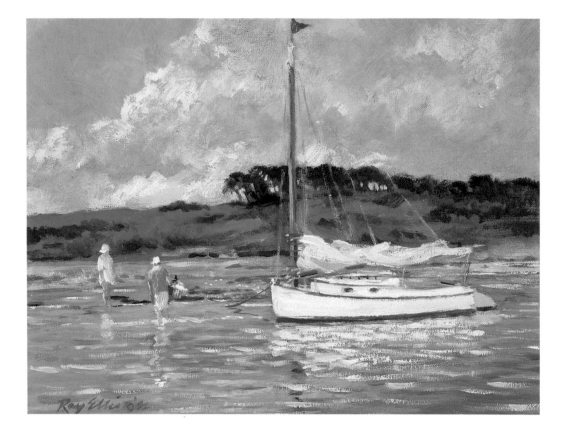

W hen you sail a catboat, one of the pleasures is raising the centerboard,
getting in close and wading ashore for a picnic.

Lee Side of Chappy • 1992 • OIL • 11 X 14 IN. (27.9 X 35.6 CM)

F rom my paintings one might gather—quite correctly—
that picnics are very popular on the Island.

Picnic for Four • 1988 • WATERCOLOR • 8¾ X 11 IN. (22.2 X 27.9 CM)

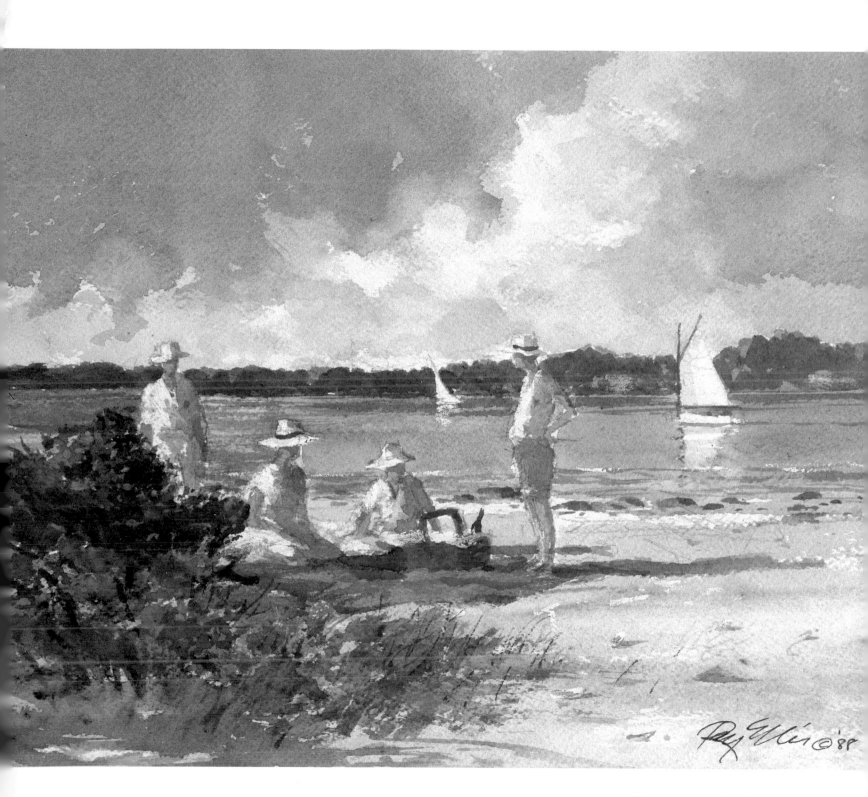

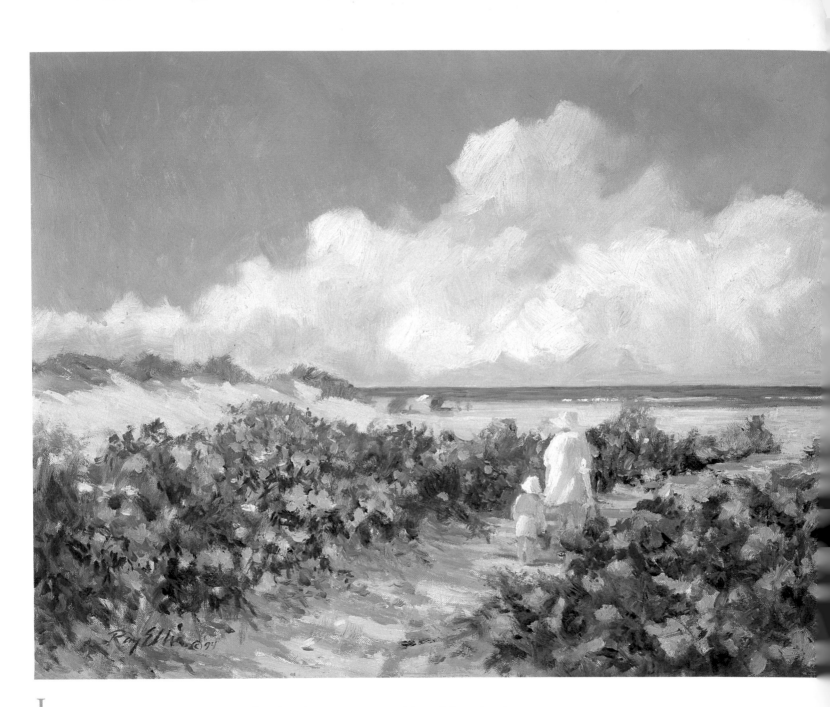

In early summer the beach paths are lined with rugosa roses, white, pink and red.
A young mother takes her child for what might be his first glimpse of the ocean.

To the Beach • 1994 • OIL • 16 X 20 IN. (40.6 X 50.8 CM)

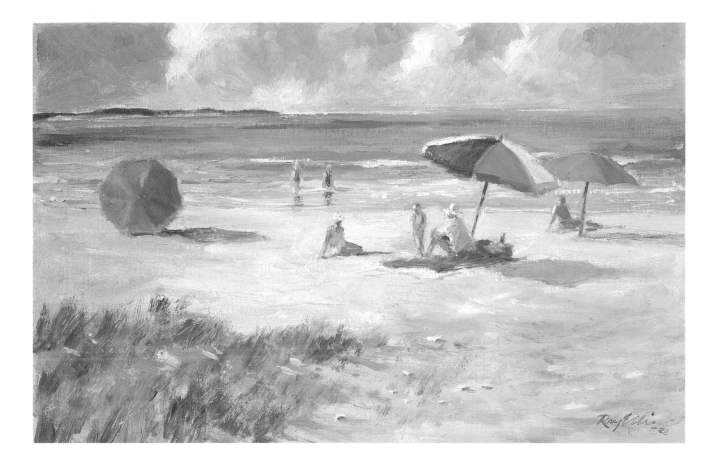

Various colored umbrellas dot the sand and make shadowy patterns on the beach.

Sunny Beach · 1988 · OIL · 12 X 18 IN. (30.5 X 45.7 CM)

Overleaf:

In this painting, I experimented with a technique often used by the American Impressionist George Inness—underpainting the canvas with a reddish umber. It somehow gives the painting a translucence and richness unattainable with more traditional methods. This long, narrow, light-filled landscape was, to me, the perfect subject for this experiment.

Pogue Picnic · 1991 · OIL · 10 X 24 IN. (25.4 X 61 CM)

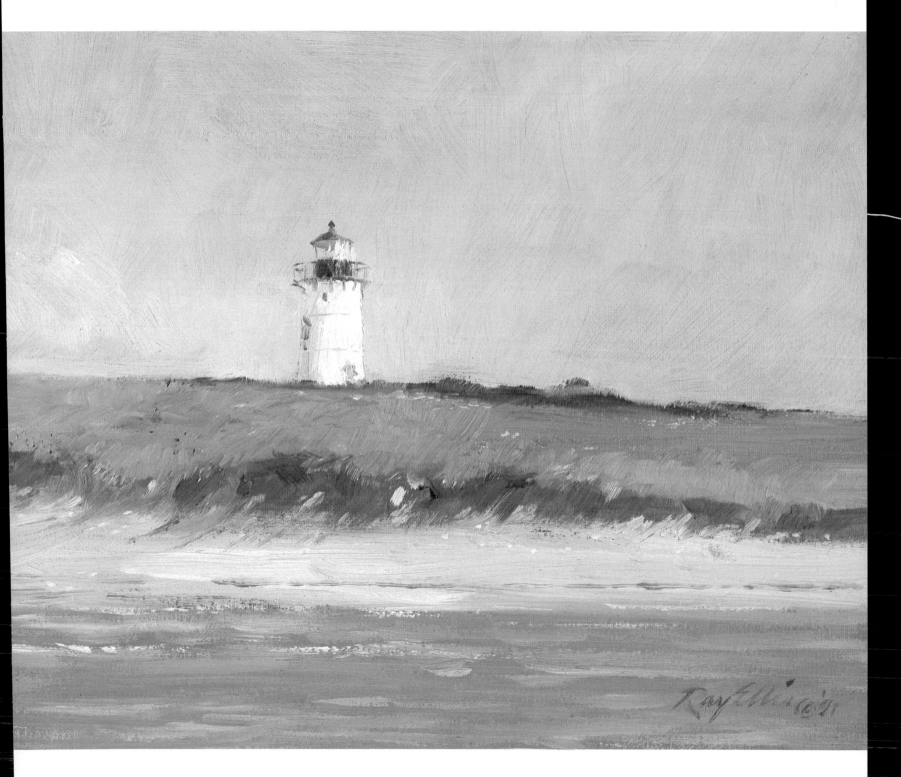

Catboats are not ordinarily known for long-range cruising but are ideal for
"Gunkholing" around Vineyard waters.

Across the Bay • 1993 • WATERCOLOR • 11 X 15 IN. (27.9 X 38.1 CM)

This is the first print I did to benefit the Martha's Vineyard Striped Bass and Bluefish
Derby. It typified the patience of the surf fishermen as they stood in the water, cast after
cast, on one of the Island's most beautiful beaches. I particularly like the reflections of
the foul weather gear in the wet sand.

Wasque Fishermen • 1988 • WATERCOLOR • 23 X 17 IN. (58.4 X 43.2 CM)

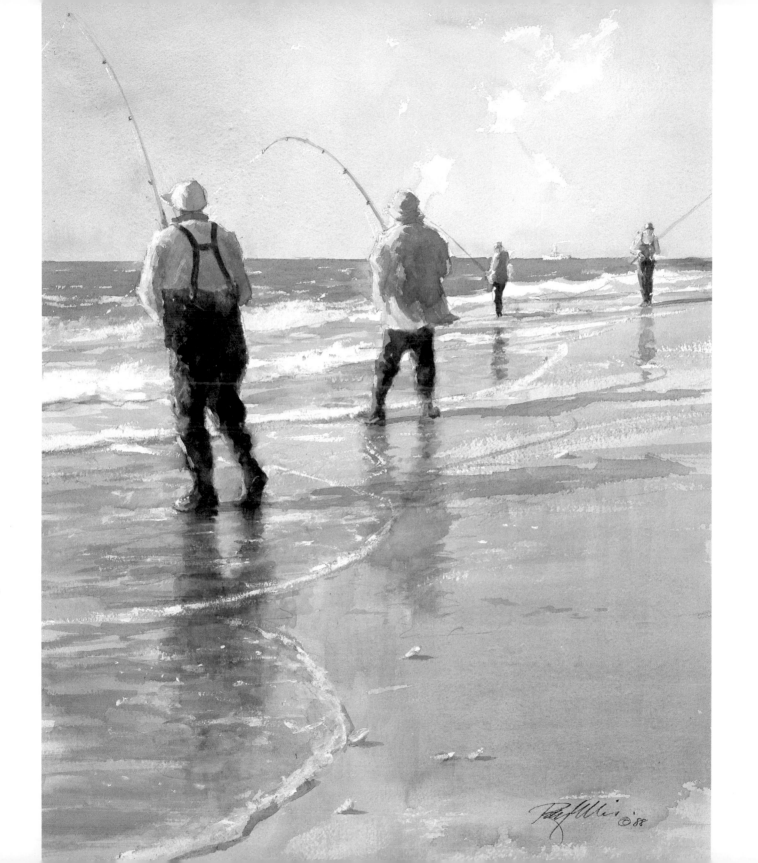

Oak Bluffs and Vineyard Haven

Oak Bluffs, the town that turned the Vineyard into a summer resort . . . Fabulous gingerbread houses . . . The glowing Japanese lanterns of Illumination Night . . . The Flying Horses, oldest carousel in America . . . Vineyard Haven, where the ferry usually docks, and therefore almost everyone's first view of the Island . . . The most year-round residents of any town.

State Beach, between Oak Bluffs and Edgartown, runs for several miles along Nantucket Sound. In early summer the small dunes are carpeted with pink and white rugosa roses and the water is often the color of the Caribbean. The gentle surf makes this a popular beach for swimming and family picnics.

A Day at the Beach · 1990 · OIL · 20 X 30 IN. (50.8 X 76.2 CM)

One of the oldest traditions on the island is Illumination Night, held every August in the campground in Oak Bluffs. Shortly after the Civil War, a land company used fireworks and candle-lit Japanese lanterns to help sell property. The land company is long-gone, but the lanterns are still lit annually throughout the Victorian campgrounds.

Illumination Night • 1994 • OIL • 16 X 20 IN. (40.6 X 50.8 CM)

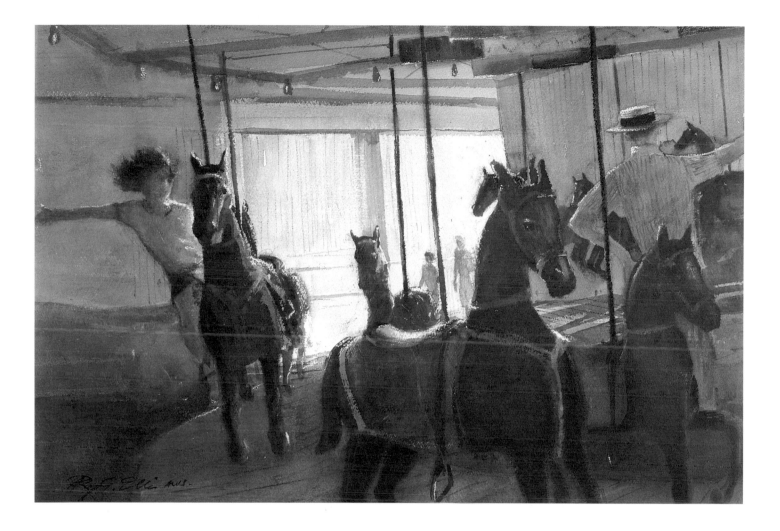

The Flying Horses Carousel in Oak Bluffs, built in the 1870s, is the oldest operating carousel in the nation. Owned and operated by the Martha's Vineyard Preservation Trust, the Flying Horses is a magical attraction for children and adults alike. I tried to recapture my childhood thrill of grabbing the brass ring.

The Brass Ring • 1978 • WATERCOLOR • 17 X 25 IN. (43.2 X 63.5 CM)

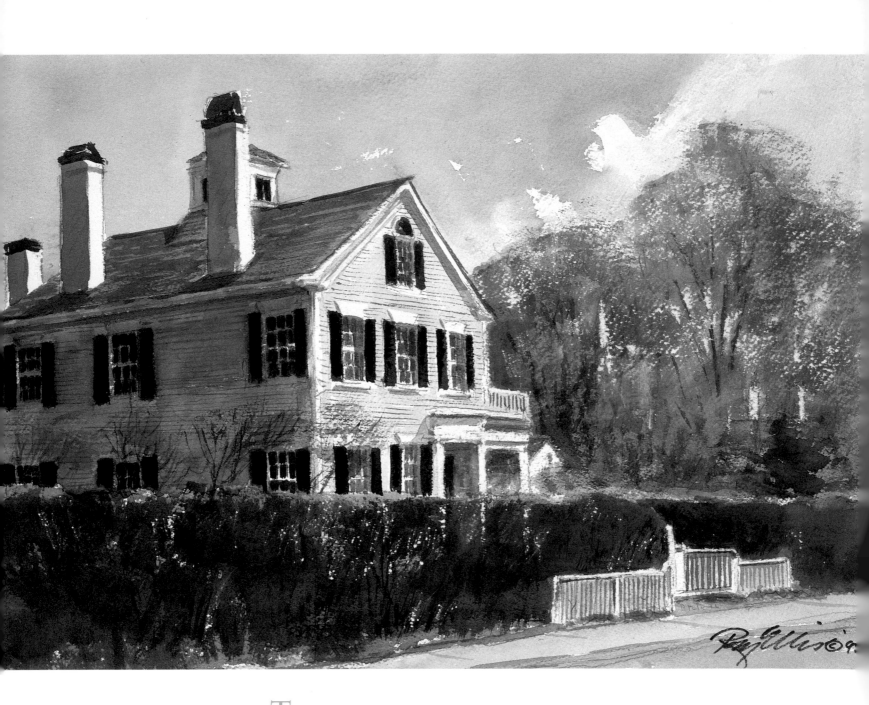

There are many beautiful old houses on William Street in Vineyard Haven, among them this graceful yellow whaling captain's home with a cupola affording a view of the harbor.

William Street, Vineyard Haven • 1993 • WATERCOLOR • 10 X 14½ IN. (25.4 X 36.8 CM)

A favorite gathering place for Islanders and visitors alike is the Black Dog Tavern. In summer it is jammed with tourists coming off or going on the ferries in Vineyard Haven. In winter it becomes a warm, cozy retreat for residents and a few brave souls who venture from the mainland. Half models and quarter boards adorn the walls and beams. A wood stove has replaced the old fireplace. I missed the fireplace, so I put it back in.

Coffee at the Black Dog • 1993 • OIL • 9 X 14 IN. (22.9 X 35.6 CM)

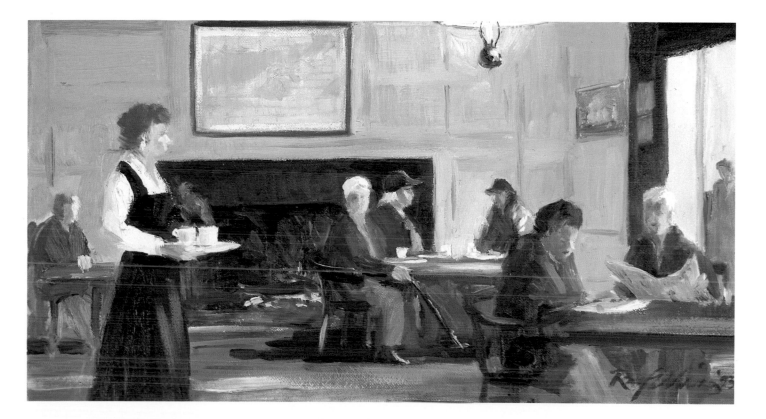

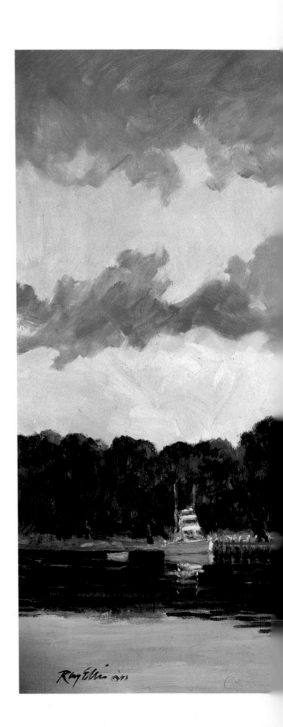

Lambert's Cove Cemetery is one of the most beautiful on the Island.
I sketched this one Memorial Day weekend. Small American flags placed
on some of the graves fluttered in a chilly May breeze.

Memorial Day · 1993 · OIL · 11 X 14 IN. (27.9 X 35.6 CM)

Lake Tashmoo, between Vineyard Haven and West Tisbury, is a little bit
of England on the Vineyard. The shoreline reminds me of the Upper Thames
with its moss-covered rocks, large limbs overhanging the water and enormous
serenity. The only sound I heard as I sketched for this painting one evening
in late summer was a flight of honking geese.

Tashmoo Evening · 1993 · OIL · 36 X 60 IN. (91.4 X 152.4 CM)

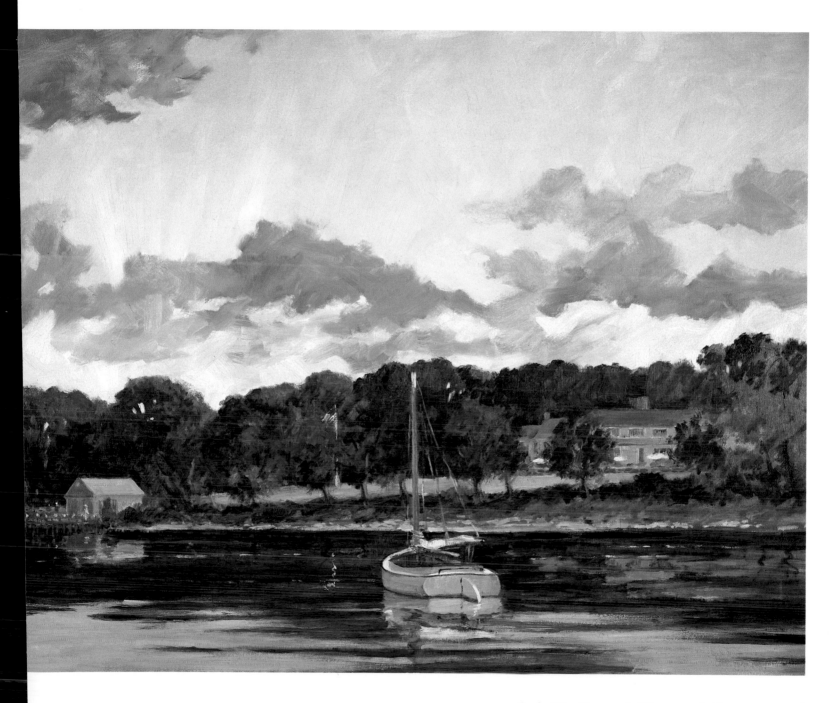

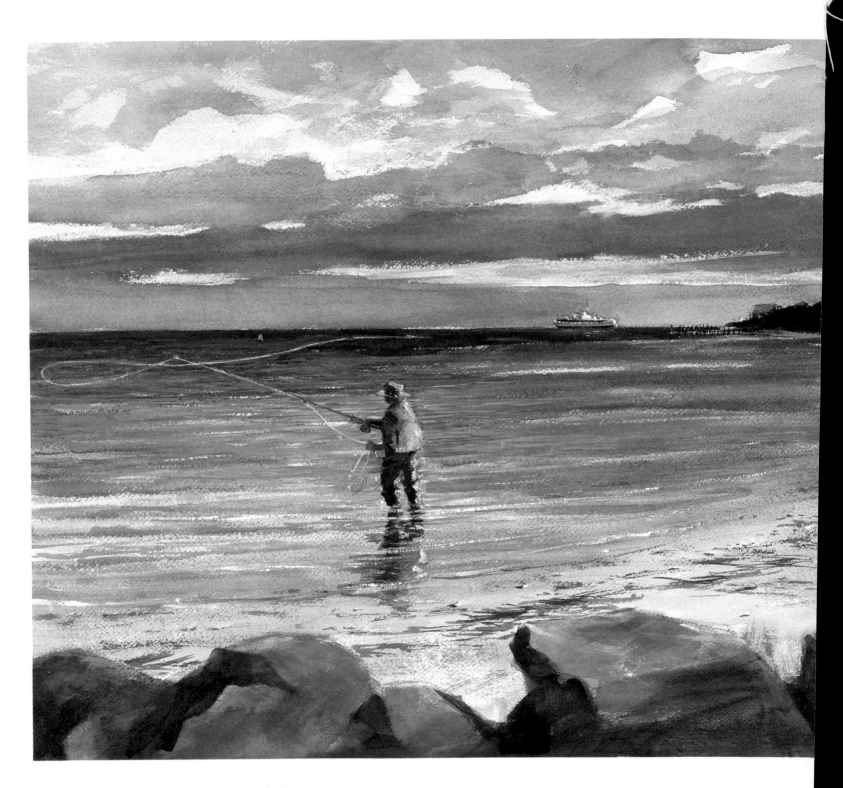

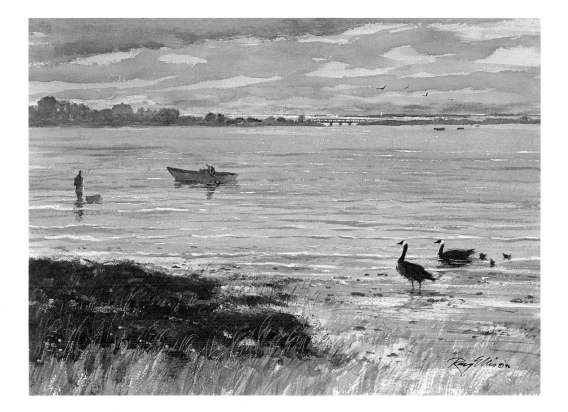

Saltwater fly fishing is a fast-growing sport. Early morning on the northwest end of the Island is a favorite time and place. This painting shows the early ferry leaving Vineyard Haven.

Fly Fishing the North Shore · 1993 · WATERCOLOR · 16¾ X 24 IN. (42.5 X 61 CM)

A friend and long-time resident of East Chop took me to this remote spot on the pond. I was having difficulty deciding which view I wanted to paint. As we approached the water, two families of geese, trailed by their goslings, paddled by. They never even saw us. My mind was instantly made up on what to paint.

Sengekontacket Morning · 1992 · WATERCOLOR · 16 X 22 IN. (40.6 X 55.9 CM)

Holmes Hole was the original name of Vineyard Haven. This tranquil scene belies the busyness of the harbor with ferries and other vessels coming and going.

Ketch at Holmes Hole • 1993 • WATERCOLOR • 11 X 11¾ IN. (27.9 X 29.8 CM)

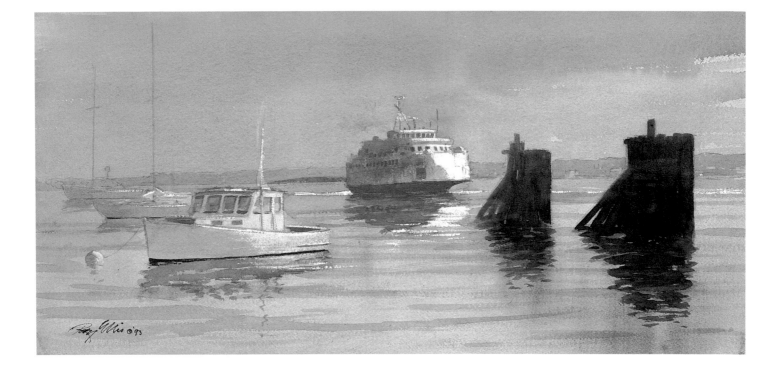

The life line to the Vineyard are the ferries that take us and our supplies to and from the Island. It is not always easy to get here without reservations. This gives us a wonderful feeling of isolation as well as a feeling of frustration.

Vineyard Haven Arrival • 1993 • WATERCOLOR • 12 X 24½ IN. (30.5 X 62.2 CM)

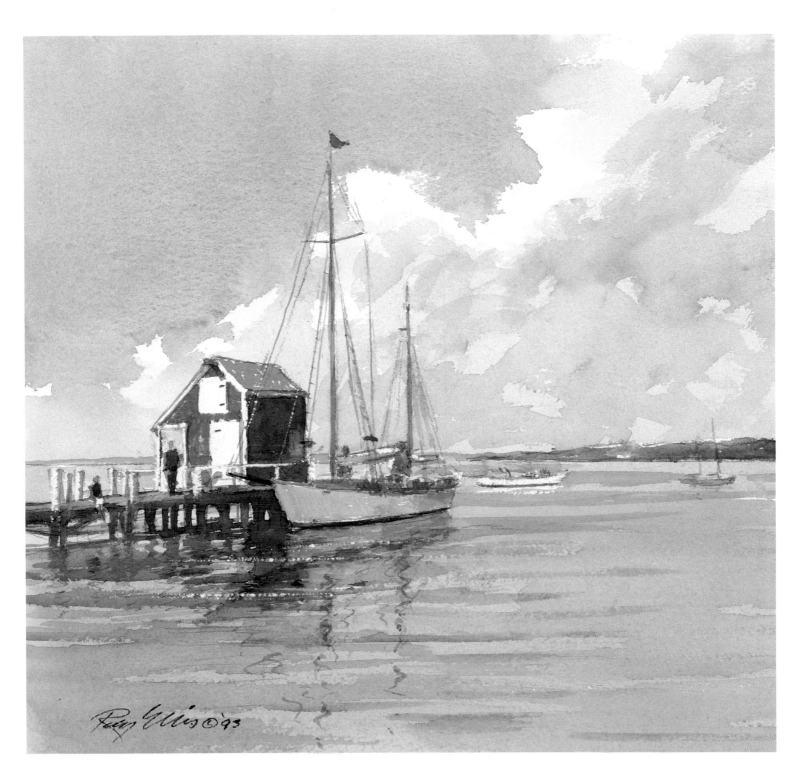

Ray Ellis ©'93

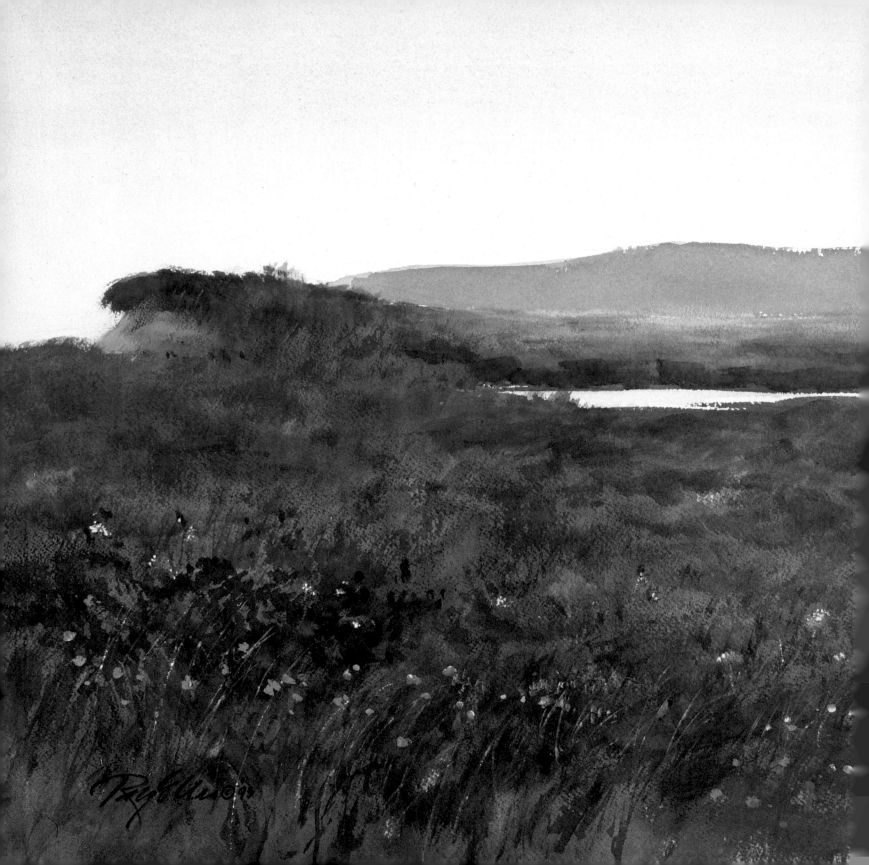

Up-Island

Smaller towns here, with rarely a traffic jam . . .
West Tisbury, Island crossroads, boasting Alley's
General Store and the annual Agricultural Fair . . .
Chilmark, a handful of buildings clustered around
Beetlebung Corner, with beautiful shores and the
Island's tallest hills . . . Menemsha, every artist's
and photographer's favorite fishing village . . .
Gay Head, ancient land of the Indians, named
after the gorgeous multicolored clay cliffs.

This is the epitome of a simplified watercolor. There are basically only three values —
the pale pink sky, the lavender hills of Chilmark, the vast expanse of green marsh.
A sliver of the small pond slices through the grasses. This is my wife's favorite painting.

Dusk at Quansoo · 1993 · WATERCOLOR · 15 X 25 IN. (38.1 X 63.5 CM)

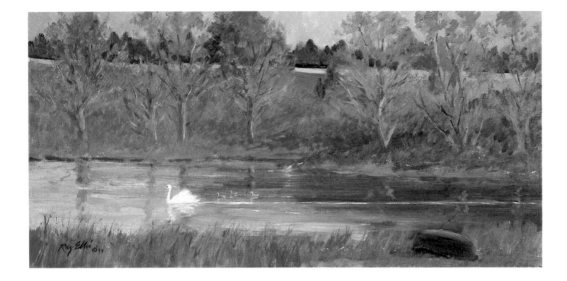

Parsonage Pond in West Tisbury is an oasis of peace and quiet, in spite of being so close to a busy road and to the town. On this particular day, a lone swan glided through the water leaving only a silver wake.

The Swan • 1993 • OIL • 15 X 30 IN. (38.1 X 76.2 CM)

Legend has it that this oak is the oldest tree on the Island. It has suffered considerable damage from hurricanes and strong winds over the years. But it's an old warhorse, and I love the configuration of the limbs.

The Legendary Tree • 1993 • OIL • 11 X 14 IN. (27.9 X 35.6 CM)

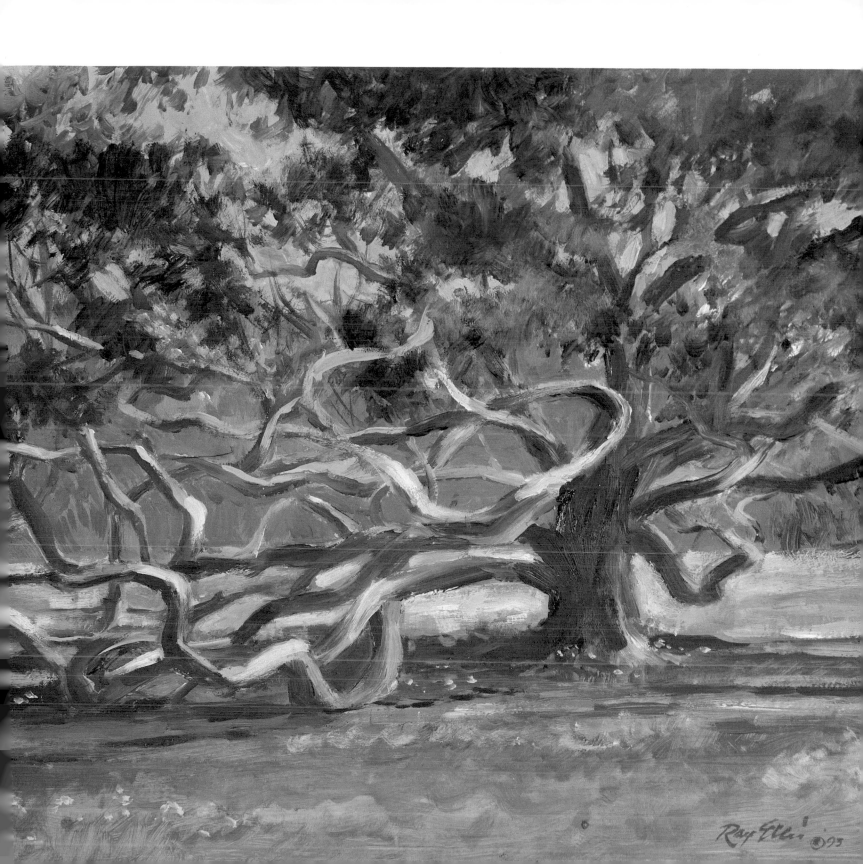

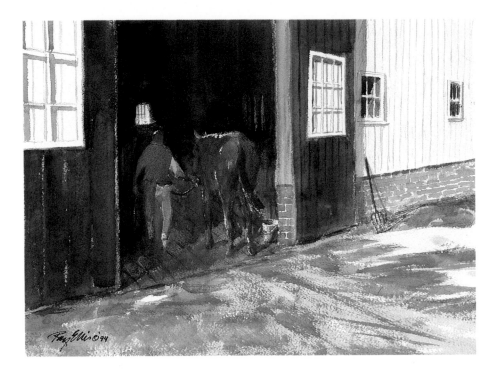

Most of us love old barns, but no one loves them more than a friend of mine in West Tisbury. This horse barn, built around 1790 in Winchendon, Massachusetts, was dismantled by him, brought to the Island and reassembled. On a winter day, I found him leading one of the horses back into his barn. I liked the contrast of light and shadow.

To the Barn • 1994 • WATERCOLOR
10¼ X 13¾ IN. (26 X 34.9 CM)

While visiting my friend who restores old barns, I climbed up in the hayloft. I found this wonderful calico cat focusing on a mouse.

The Barn Cat • 1994 • OIL
9 X 12 IN. (22.9 X 30.5 CM)

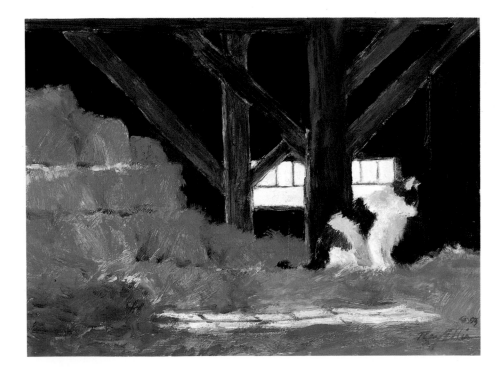

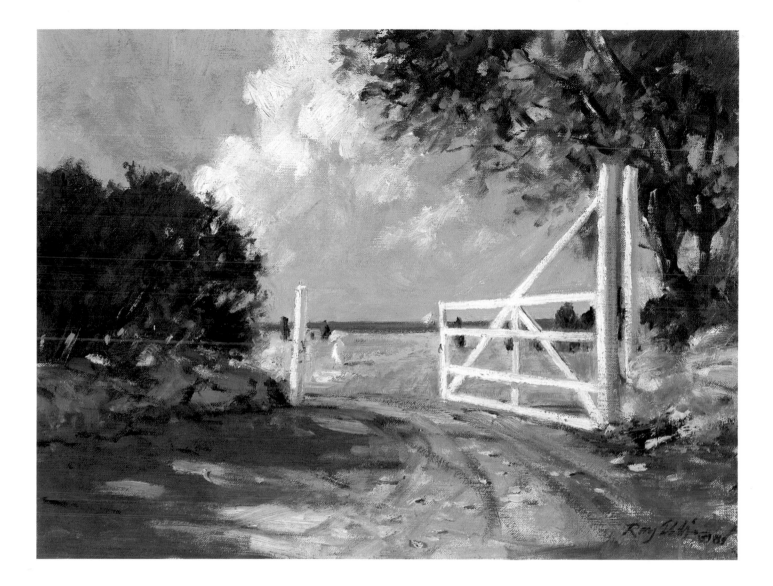

This is the quintessential Vineyard gate. Sometimes they are painted white; sometimes they are allowed to weather; sometimes they are open; sometimes they are chained shut. Late one fall day, I found this gate open, and it beckoned me toward the sea beyond.

Vineyard Gate · 1989 · OIL · 12 X 16 IN. (30.5 X 40.6 CM)

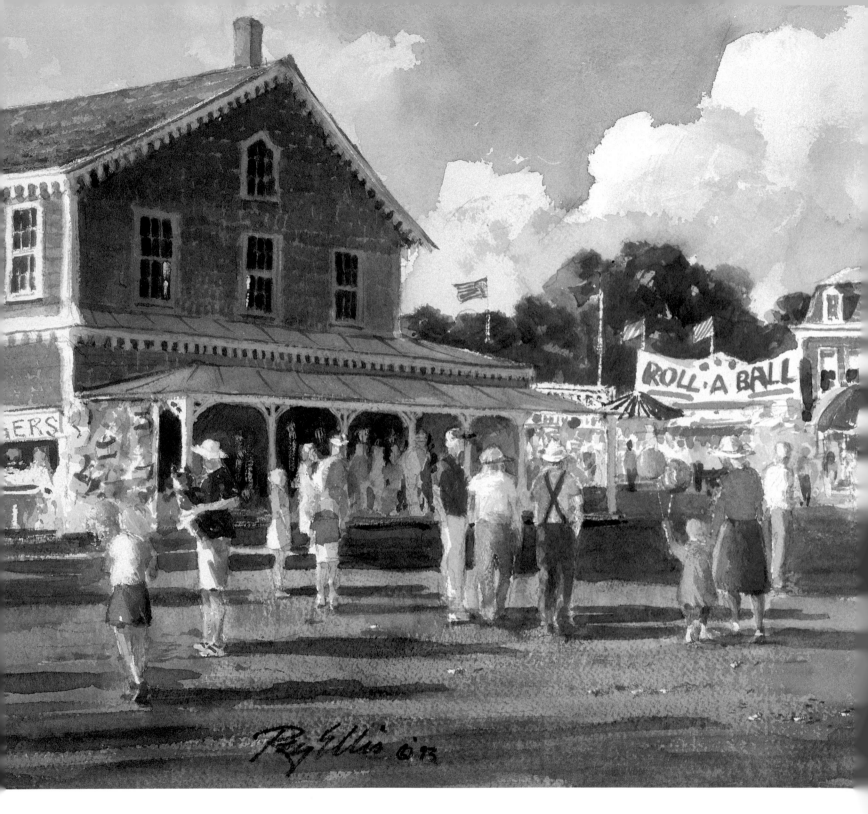

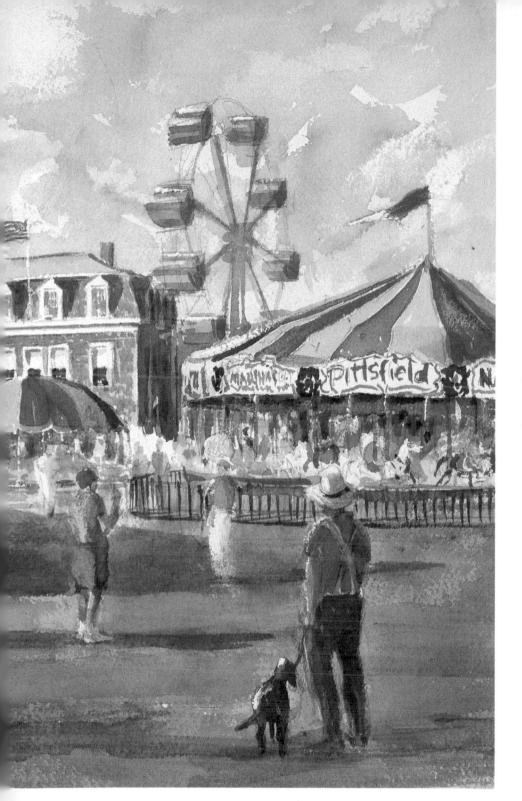

Held every August on the grounds of the Agricultural Hall in West Tisbury, the fair brings Vineyarders and tourists, old and young, from every part of the Island. The events include everything from pie-baking contests to livestock shows to carnival rides and games.

The Agricultural Fair • 1993 • WATERCOLOR
12¼ X 21¼ IN. (31.1 X 53.9 CM)

A crossroads in Chilmark is named for the large stand of
Beetlebung trees that turn a brilliant red in the fall.

Beetlebung Corner • 1993 • OIL • 12 X 18 IN. (30.5 X 45.7 CM)

The Vineyard boasts many wonderfully picturesque churches.
This Greek Revival in Chilmark is one of the oldest.

After Church—Chilmark • 1993 • WATERCOLOR • 9 X 15½ IN. (22.9 X 39.4 CM)

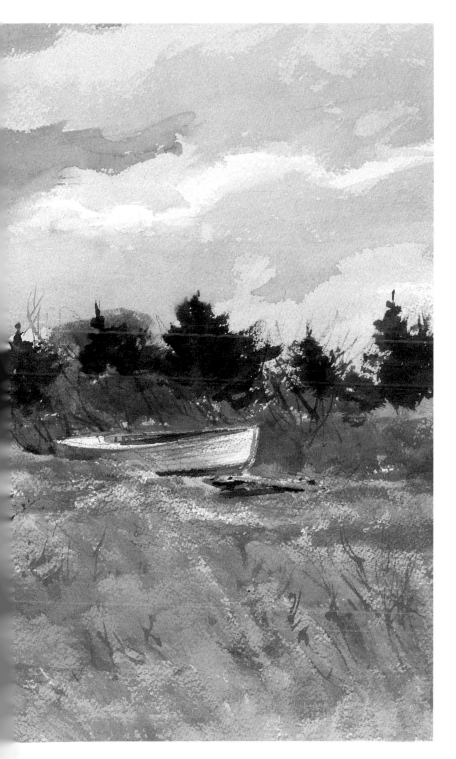

High on a hill overlooking Menemsha Pond stands an old Victorian house. In summer the house is full of activity and laughter. But once the season has ended, it becomes a silent and very lonely sentinel.

Off-Season · 1993 · WATERCOLOR · 13 X 24 IN. (33 X 61 CM)

Wildflowers abound in fields all over the Island. One day we picked this bouquet and put it in an old copper bucket. I liked the looseness of the arrangement in contrast to the austerity of the metal container.

Island Still Life · 1981 · WATERCOLOR
19 X 28 IN. (48.3 X 71.1 CM)

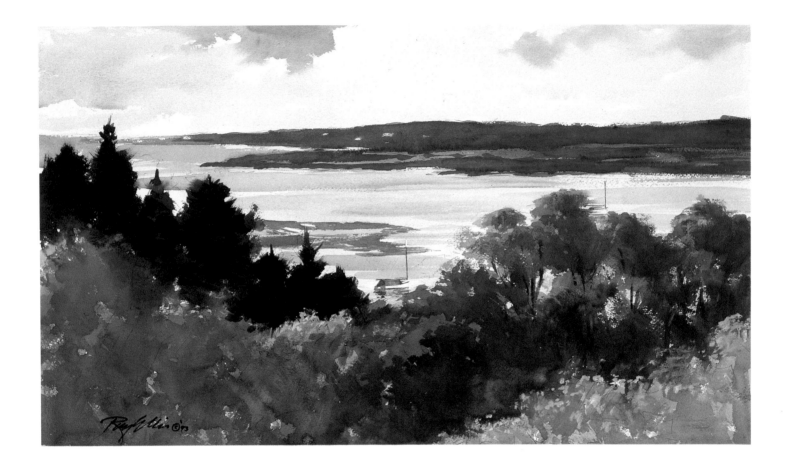

On the road out to Gay Head, there is a spectacular view of Menemsha Pond. In late fall most of the boats have been stored for the winter. I loved this lonely little catboat with her blue cover, riding proudly as though it were still summer.

Fall—Menemsha Pond • 1993 • WATERCOLOR • 14½ X 24¼ IN. (36.8 X 61.6 CM)

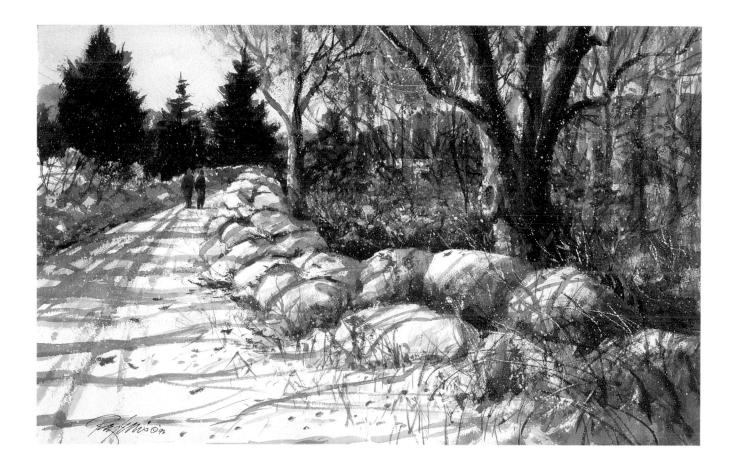

When the first snow falls, we drive down some of the remote roads to see
the new snow on the rocks and meadows.

Early Snow—Tea Lane • 1993 • WATERCOLOR • 13¼ X 22 IN. (33.7 X 55.9 CM)

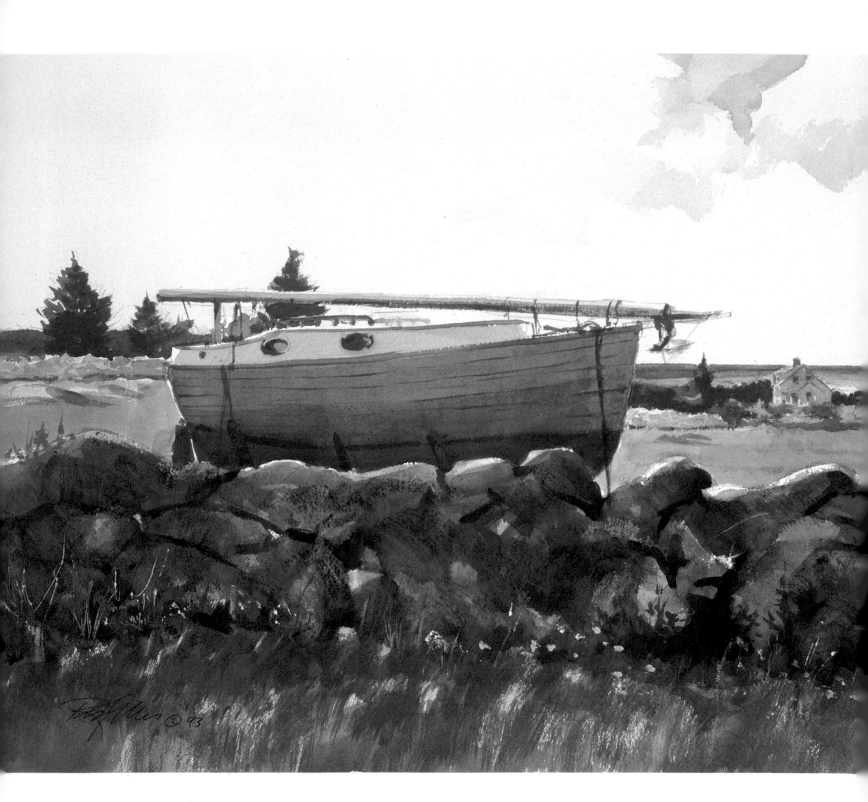

One spring a friend from Chilmark took me to places I had never been up-Island. One of the scenes that struck me was this sloop up on a cradle behind an old stone wall. It looked out of place so far from the sea.

Up for Winter—Chilmark · 1993 · WATERCOLOR
17¼ X 28½ IN. (43.8 X 72.4 CM)

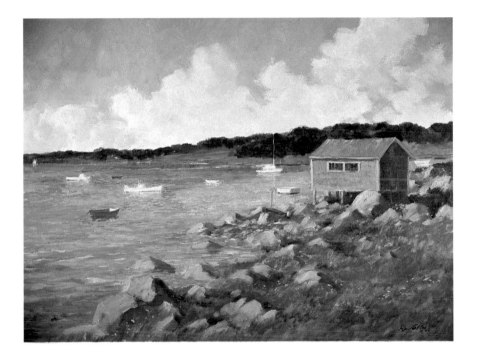

This up-Island pond is a familiar subject to many artists, because it provides unlimited opportunities for good composition. I chose this particular one to accentuate the boathouse on the rocky shore, and I added a red dinghy for color—artist's license!

Quitsa Pond · 1987 · OIL · 30 X 40 IN. (76.2 X 101.6 CM)

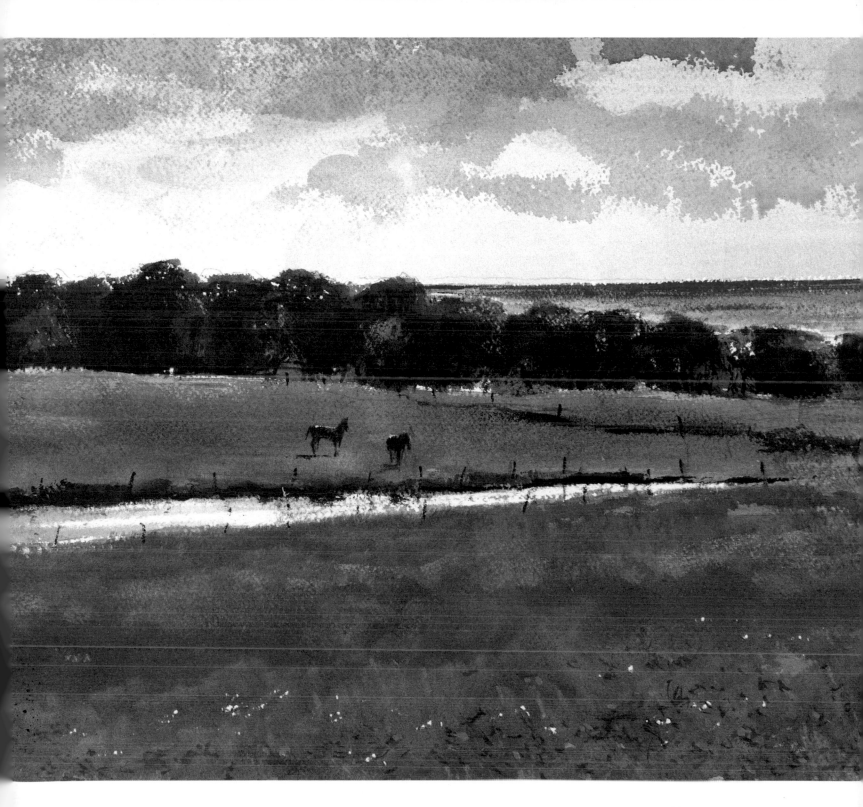

Pages 124–125:

Shortly before Beetlebung Corner, there is a farm on Middle Road that I have always loved. You can see the ocean just over the stand of trees behind the pond. This tranquil, pastoral scene hangs over our mantel and gives us quiet joy daily.

A Chilmark Pond · 1989 · WATERCOLOR · 11 X 25 IN. (27.9 X 63.5 CM)

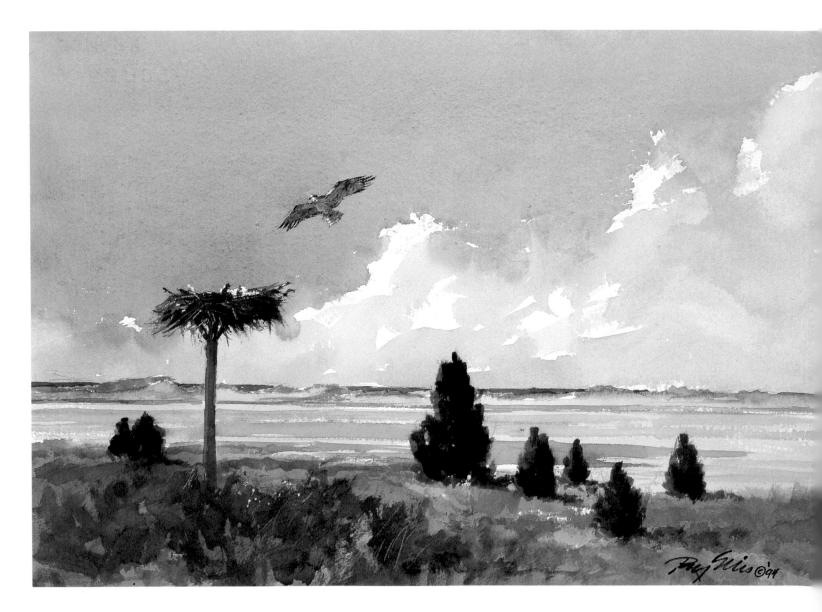

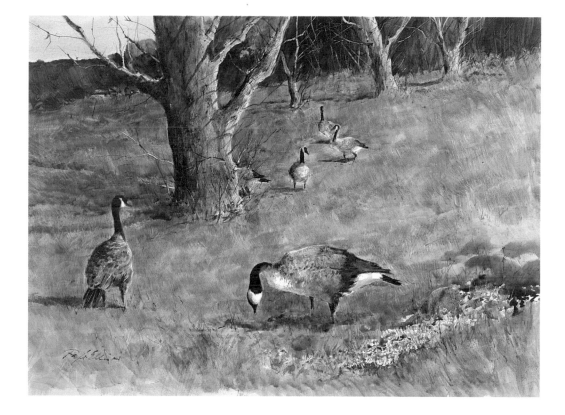

This is one of the first paintings I ever did on Martha's Vineyard. Canada geese and Vineyarders endure a love/hate relationship. The geese and their residue are everywhere—on golf courses, lawns and in ponds—but there is no doubt that they are beautiful, especially when flying in formation on a clear fall day. This flock was foraging near a stone wall in an up-Island orchard. We have kept the original in our personal collection.

Geese in the Orchard • 1973 • WATERCOLOR • 19 X 28 IN. (48.3 X 71.1 CM)

Opposite:

Ospreys have made a great comeback in the past ten years. In addition to finding the nests in dead trees, they also may be seen on man-made platforms on high poles.

The Osprey Nest • 1993 • WATERCOLOR • 12 X 16½ IN. (30.5 X 41.9 CM)

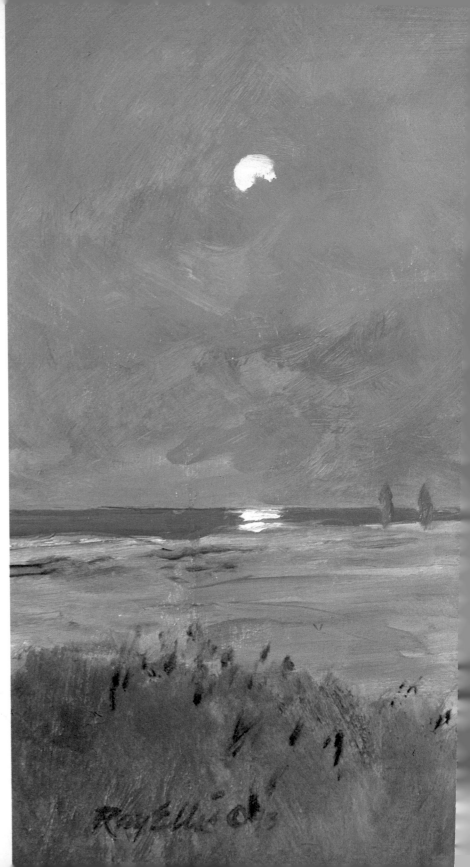

One of the great pleasures of Vineyard life is being invited to a traditional clambake. The figures standing around the fire reflect the embers on their silhouetted forms. An early moon highlights the smoke. I moved the position of the moon into the painting, because I wanted its silvery cast on the water.

The Clambake—Black Point · 1993 · OIL
12 x 16 IN. (30.5 x 40.6 CM)

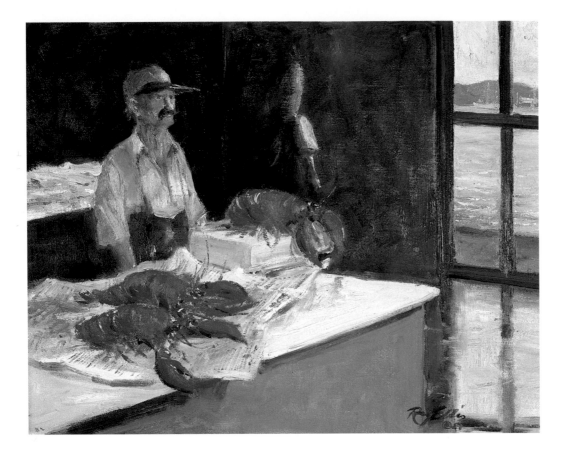

Seafood abounds on the Menemsha Docks. I liked the contrast of the dim light inside Poole's fish market, the wet floor and the brilliant red of the cooked lobsters on a white newspaper.

Cooked Lobsters · 1987 · OIL · 16 X 20 IN. (40.6 X 50.8 CM)

Perhaps one of the reasons I love the Vineyard is that so many things have not changed over many years. The fishing village of Menemsha is a prime example.

Fishing Boats—Menemsha · 1993 · WATERCOLOR · 10 X 15 IN. (25.4 X 38.1 CM)

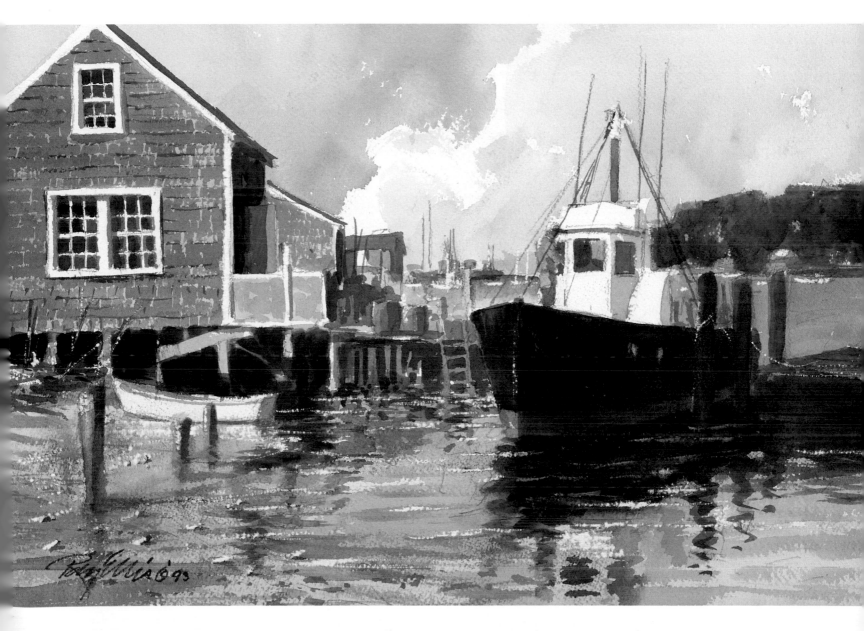

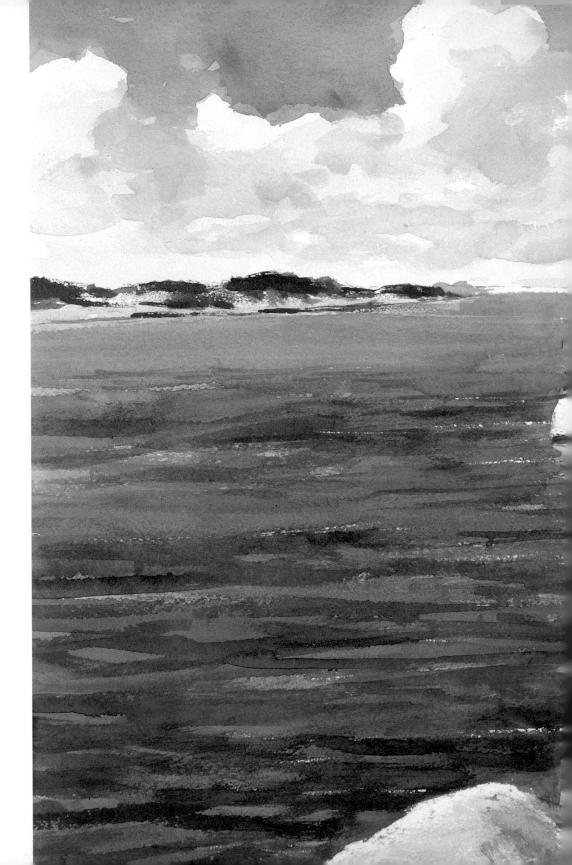

Tidal currents run swiftly
through Menemsha Inlet.
Here fishermen prepare a boat
to leave on the outgoing tide.

Menemsha Fishermen · 1994
WATERCOLOR · 15 X 25 IN.
(38.1 X 63.5 CM)

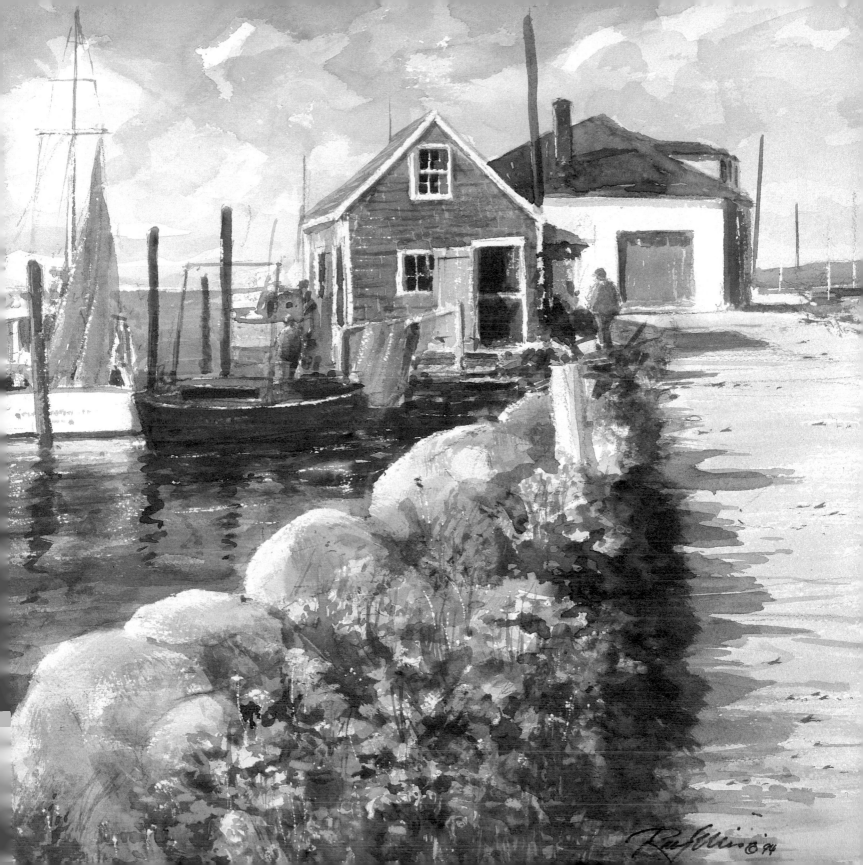

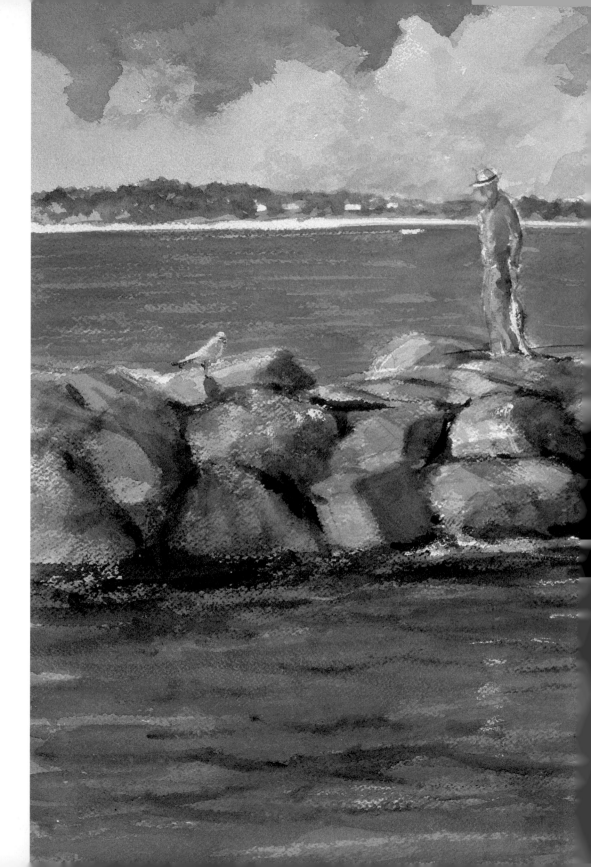

One of the favorite spots for serious fishermen of all ages is the jetty at Lobsterville Beach in Gay Head. The interesting and varied positions of the fishermen intrigued me.

Fishing the Breakwater · 1989
WATERCOLOR · 14¾ X 24½ IN.
(37.5 X 62.2 CM)

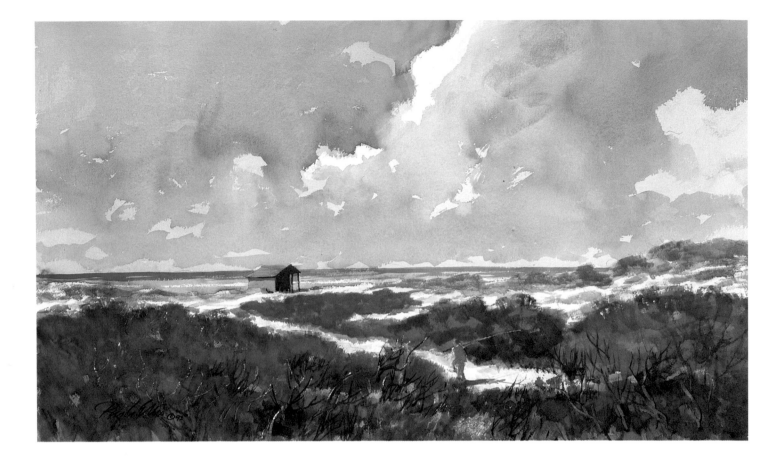

In fall the paths leading to the beach are surrounded by dark reddish brown underbrush. This seasonal reminder is tempered by the seagrass still green on the nearby dunes.

Fisherman's Shack, Gay Head · 1993 · WATERCOLOR · 14 X 24 IN. (35.6 X 61 CM)

Overleaf:

Gay Head Light stands on the edge of a cliff. I liked this view, looking up toward the light. Clouds rise from below the cliff, signaling a sharp drop to the sea beyond.

The Lightkeeper—Gay Head · 1993 · OIL · 15 X 30 IN. (38.1 X 76.2 CM)

On a path leading down to the beach near Gay Head, I came upon a view of the cliffs from a vantage point that was new to me. For the vast moors above the cliffs, I used mostly hues of greens and browns. A high horizon provided drama to this painting.

Fall, Gay Head Cliffs • 1987 • OIL • 40 X 48 IN. (101.6 X 121.9 CM)

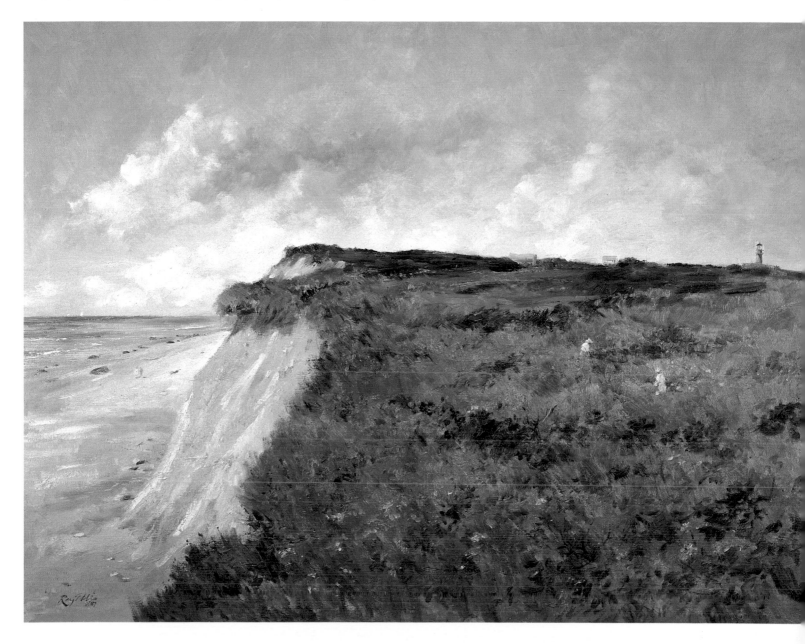

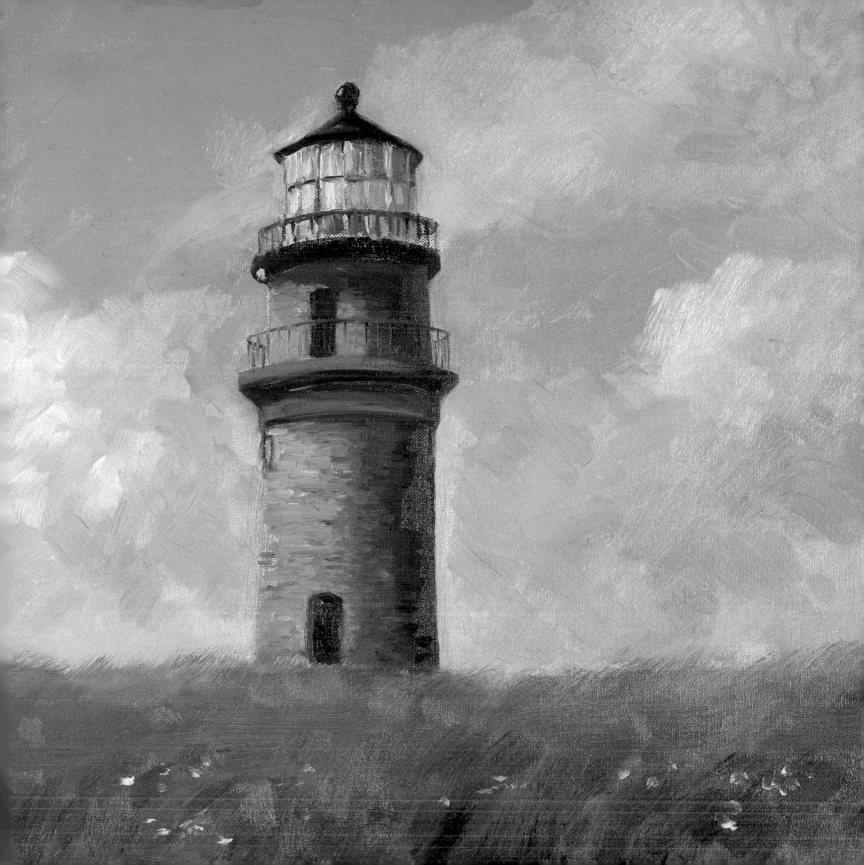

Index

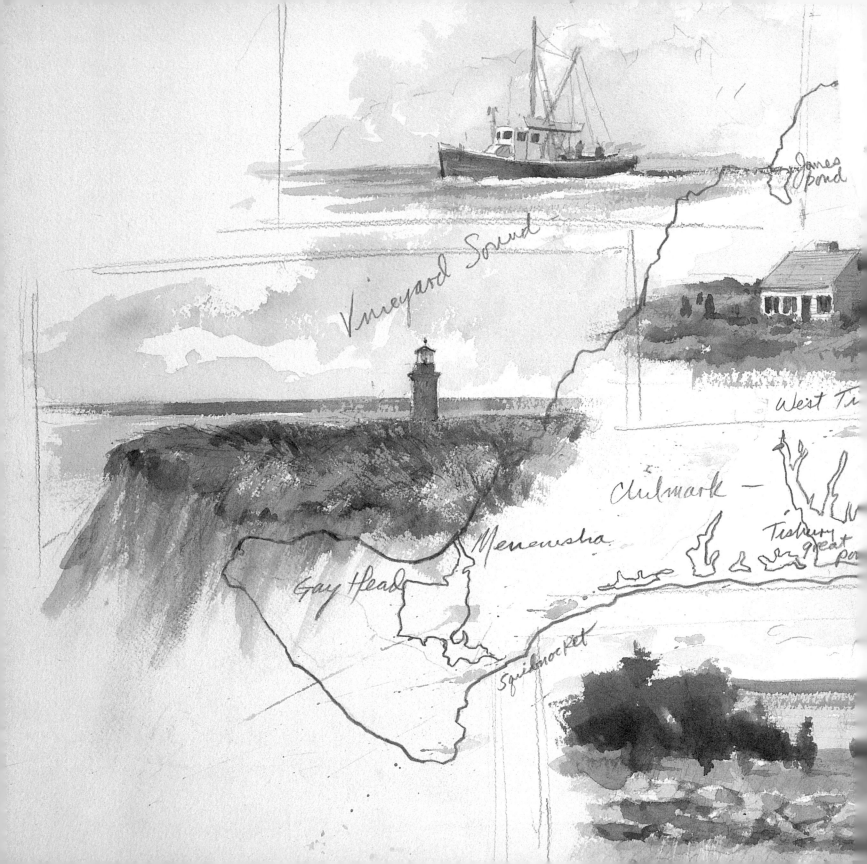

Vineyard Sound

James Pond

West T

Chilmark —

Tisbury great p

Menemsha

Gay Head

Squibnocket